Keys to Successful Color

Some live and learn
life is for growing

Some live and die,
never knowing.

—*Illon M. Sillman*

Keys to Successful Color

A Guide for Landscape Painters in Oil

Watson-Guptill Publications/New York
Pitman Publishing/London

To June,
who made my dreams hers, and has worked with me
so that they could come true, this book is dedicated.
No one else is more deserving.

First published 1979 in the United States and Canada by Watson-Guptill Publications,
a division of Billboard Publications, Inc.
1515 Broadway, New York, New York 10036

Library of Congress Cataloging in Publication Data
Caddell, Foster.
 Keys to successful color.
 Includes index.
 1. Landscape painting—Technique. 2. Color in art.
I. Title.
ND1342.C26 1979 751.4'5 78-27779
ISBN 0-8230-2580-2

Published in Great Britain by Pitman Publishing
39 Parker Street, London WC2B 5PB
ISBN 0-273-01346-7

Manufactured in Japan

First printing, 1979

Acknowledgments

Many people contributed to the final product that you hold in your hands, and without their help it would not have become a reality. I therefore would like to express my appreciation to the following:

Don Holden, who from the beginning has with enthusiastic persuasion motivated me to put my teaching thoughts into book form.

Marsha Melnick, who took over and helped organize a logical approach to my original ideas for this sequel. From our first meeting, her warm personality made working with her a pleasure.

Bonnie Silverstein, for helpful editing.

Jay Anning, for the attractive design of this book.

Earl Robinson, for his patient cooperation in trying to attain the best photography we felt possible.

My wife June, who did more than type the manuscript. Her help in the initial editing of my rough draft made for a precise and understandable text on a complicated and technical subject.

And the many people who purchased my first book who, by writing and phoning about how it helped them, gave me the encouragement to write this sequel.

Contents

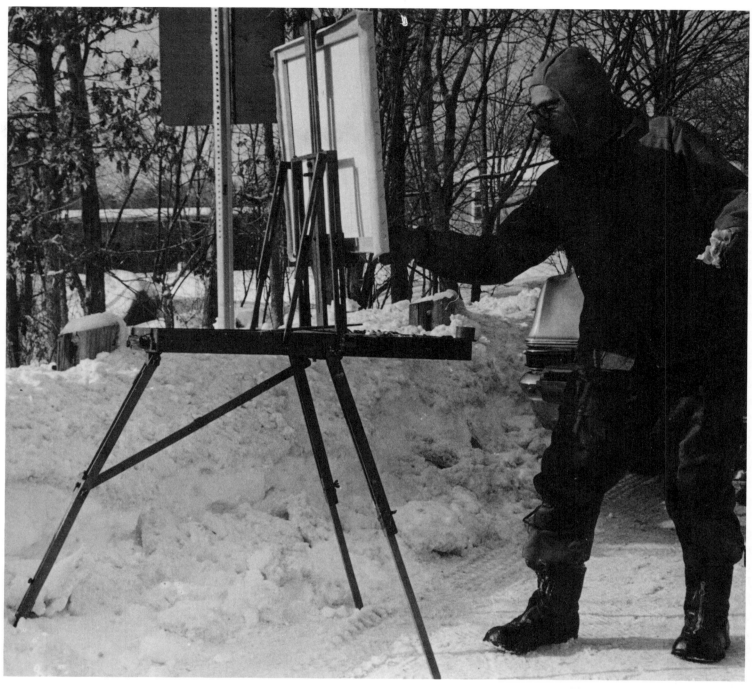

Photo: Erwin Goldstein, *Norwich Bulletin*

Inasmuch as throughout this book I stress the importance of going out and painting from nature, regardless of the weather, you might be interested in seeing this particular photo. It was taken by the local newspaper reporter when he was out looking for material for a story after one of our big storms. It was taken when I was actually working on the painting, *Sunday Morning* (page 72)—and the temperature was about ten degrees. Looking in my diary of Sunday, January 22,

1978, I now note the entry: "Alarm off at 5:45AM—very cold, eight degrees. After breakfast, out at 7AM to work on snow painting—worked till 9AM—hands cold. When I got back to studio, fifteen degrees."

Later, when I was talking to my friend Peter Helck (who wrote the forward for my first book), and he was remarking on how he found it difficult to overcome a tightness in his work, I suggested (facetiously) that he work with gloves on!

Introduction

First, I'd like to say how pleased I am with the response to my previous book, *Keys to Successful Landscape Painting.* Because of your requests for more information, and the encouragement of my publishers, I'm happy to offer you this new book. The idea of showing the right and wrong way to paint different aspects of a landscape, in the form of "keys" was most enthusiastically received, so I'm continuing to use this same format here, but this time emphasizing keys to successful *color* in landscape painting. Since color is going to be the dominant consideration and theme this time, I'm fortunate to have many more pages reproduced in full color. I've even chosen to reproduce a few paintings in color that were in black-and-white in my first book, because I feel that there is still much you can learn from seeing them in color, especially with the additional principles I'll discuss in this volume. The majority of the paintings reproduced here, however, were painted especially for this book, to illustrate each key.

As I made the paintings, I showed them to my classes and explained the specific problems and solutions that are presented here. One of my students remarked jokingly that I was painting much better since I read my first book! It was a good point, taken in fun. But seriously, I hope you've read and digested my previous keys on painting landscapes in general, so that we can get into the more advanced problems and solutions using color in landscape painting, and discover how to handle it in the final stages of a landscape. A note for those who have read my first book: look for many of the points I took up with you there in the good and bad examples in this book. I won't have room to go into them in detail here, but, as I said in the conclusion to that book, learn to "read" paintings and see if you can understand what an artist did and why."

The Purpose of the Book
It seems to take some students years before they are able to stand within two feet of their painting and give it the bold color and value that make it "carry" from a distance, or sense the drama of light on objects, which I delight in painting. Many students bemoan the fact that when they take their paintings home they seem to go dull and lack the sparkle they thought the work had. I hope to help you with this problem and shorten the time and struggle involved in getting your work to look more professional.

Look upon this book as though I were speaking to you as a guest in my studio being shown some of my recent paintings. First, I'll comment in general upon why the subject intrigued me initially. I'll also point out some of the color problems you should be able to spot right away, how I solved them, and how, in some cases, I captured some of the transitory effects of nature. Then, as I do in my classes, I'll say, "Come closer. Study this little passage here, and notice how it's handled," for a painting should look good at two different viewing distances. First, naturally, it should carry well and be commanding at the proper viewing distance of fifteen or twenty feet. But then, when the connoisseur or fellow artist steps up close, he should also take delight in examining the handling and use of color in various small passages. Thus, we're going to look at paintings in this book at two different viewing distances: First, I'll view and comment on the painting in general, and then, with the use of closeups, I'll take you in closer for a more detailed study and explanation of how some of the final handling is accomplished.

Because the approach in my previous book of showing you two versions of each key (the wrong and the correct solution) proved so helpful and was so well received, I'm doing the same thing again, but this time with the addition of two closeup details from each painting (with a few exceptions). By pinpointing the problem areas on my finished painting, first I'll show you the typical errors an amateur might make in handling it, then I'll compare it with a detail from my painting, and we'll study how I solved the problems. I realize that you're not all at the same early stage of painting I depicted in the "bad" examples, but I'm sure that the corrected version shows such a marked improvement over them that it will help you no matter what your level is.

The Importance of Studio Work
I'd like to stress here and now the importance of serious studio study for the preparation of *any* kind of painting. In my classes, still life is a basic *must*, and if you haven't had serious training along this line, I strongly suggest that you seek out someone who is qualified in this field and go back for thorough training. I say this, because it's exactly what I did myself. I've shown students the reproduction of *The Lewis Mill*

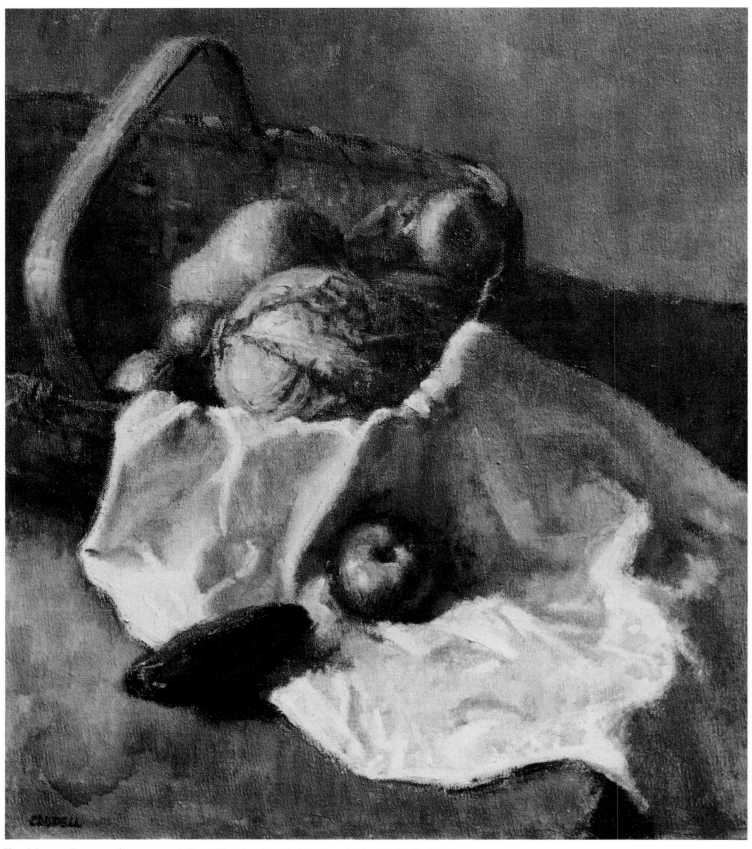

THE MARKET BASKET, *oil on canvas, 18" x 16" (46 x 41 cm), Courtesy of Mrs. Foster Caddell.*

What is a still life doing in a book on landscape? Regardless of the subject matter you prefer, painting still lifes affords an excellent opportunity to study and analyze the basics of design, color, and value essential to all types of painting. I, myself, have done many such still lifes—so, as you can see, I practice what I preach!

(on page 12 of my previous book) and have told them that, even though I could paint this well, I still returned to the classroom studio for more training. Other professionals have done this, too. Artur Rubinstein was already hailed as a great pianist when, not content with his ability, he returned to the cold, hard keyboard discipline that eventually made him one of the master pianists of all times.

Now when I say to paint still lifes, I don't mean to make pictures. As I tell my students, the picture that you get is really a bonus. You're to paint still lifes to develop your analytical perceptions and perfect your craft as you synthesize the result of your observations.

How and what students paint on canvas immediately tells me what they know and what they don't know, rather like the old saying, "Speak and remove all manner of doubt." When the students can see and render all the subtle nuances on a green glass bottle, for instance, I feel that they'll do a good job the next time they look into a stream and observe the various colors and values of the trees and bushes reflected in the water.

There's no question that studio work is easier than outdoor painting. In a studio, the direction, intensity, and color quality of light are consistent, and you're able to arrange the actual objects into an ideal composition before beginning the painting and thus can paint rather literally. This factor, of course, doesn't exist in outdoor landscape painting. Outdoors, if you find a subject that's 75% perfect, you're lucky. Then it's how you interpret and what you do with the material available that count. For this reason, in the last section of this book I'll show you a few photos of actual scenes and discuss how I interpreted them. But a word of caution: To fully cope with this aspect of painting you *must* be a good craftsman and technician, and this is what I hope to help you with.

I'll be repeating many general concepts in these keys, but that's because they're important and because I want to show you how I use the same theory and knowledge in different ways and in different paintings. Also, don't be surprised if you find me repeating some of the things that I said in my other book. In my classes, I explain the same principles over and over until students understand them so well that they become part of their own body of knowledge and can put them into practice.

Before we get into the keys themselves, I'll discuss the materials and equipment I use, and make some important comments on color in general.

Materials and Equipment

In most art classes, there's not enough emphasis placed on the mechanics of making a painting. Naturally, art is more than a craft; but, first and foremost, you must be a good craftsman. Before you can express yourself, you should be in complete command of the technical means of expression. Everything on your canvas should be deliberate and planned. The artist should run the painting, not vice versa, as is so often the case.

Brushes

I prefer a good-quality flat, white bristle brush because it has long hair and releases the paint well. I use sizes 1–4, 6, and 8. The no. 0 size is no longer available (I wish it were). I use a no. 3 round sable for detail.

At one time I used a painting knife, but I've since found a brush preferable. Many amateurs use a painting knife to achieve an "artistic" effect, but I don't feel that everyone has the necessary control, and many don't know enough to leave a happy accident alone when it happens. I do, however, use my brush in the manner of a knife quite often, but with more control.

Canvas

After years of experimentation, I've settled for a good-quality, medium-weave linen surface because linen gives the painting greater longevity. But I honestly don't feel that the student needs this—you can spend your money to greater advantage in other ways. Do get a good strong-weave cotton, though. You can determine this by looking at the *back* of the canvas. Many times I use a toned canvas, but for teaching purposes, I demonstrate on a plain white canvas, since that's how most of my students work.

Easels

You can't afford to have anything but the best and sturdiest of easels to work on outdoors. Remember, you won't be working under the ideal conditions found in the studio. The ground is uneven, "the wind doth blow," and you'll need a well-constructed easel that serves you well so you can concentrate on painting. I've used the French combination sketchbox-easel for years and find it most satisfactory. While we're on the subject of easels, try to remember to always position your easel so that the painting surface of the canvas is *not* bathed in direct sunshine. The sunlight gives colors and values a false sense of brilliance, which will fade and flatten when you take the painting indoors. Because of this, artists usually end up facing the sun; hence a broad-brimmed hat is necessary.

Palette

I find the palettes that come with the French easel too small, so I carry my large oval studio one with me outdoors. I find it well worth the added luggage. There are many different ways of laying out colors on your palette; no one way is absolutely right. The important point here is to have a system and *always* lay your colors out the same way so that your hand knows just where to go for a certain color—like knowing the keyboard of a piano or typewriter. Needless to say, you must always keep the mixing area of your palette clean. I do this when I clean my brushes after a day's painting.

Paint

I never cease to be amazed at how little students know about the colors of the paint they use. There should be a reason for every color you have in your paintbox. Some students try to get by with too few colors, and I've found some who have been indoctrinated that earth colors or alizarin crimson are not necessary. On the other hand, the paint manufacturers will produce any color that people will purchase. For instance, I've yet to find a justification for colors like cadmium yellow medium or cadmium red medium, except to fill painting kits that well-intentioned relatives purchase at Christmas time. Over the years, I've tried them all, and here's the list I've settled on for myself and for my students. I use the same palette of colors regardless of what I am painting—just as a pianist uses the same keyboard—because each color does something that none of the others will do. Yet there aren't that many—I still have to do a great deal of mixing on the canvas.

Basically, my selection represents the warmest and coolest of each color, but I must remind you, unfortunately, that there has yet to be a consistency of color specifications between the various paint manufacturers. At first, you may find it hard to understand the terminology of "warm" and "cool" in paint, because not only are the primary colors referred to as either warm or cool, but also within each individual color there's a warm and cool category. To explain further,

yellow is basically thought of as a warm color, but there's a warm yellow—cadmium yellow deep—that leans toward the orange end of the color wheel, and a cool yellow—cadmium yellow pale—that tends to the green side. To use another example, blue is basically thought of as a cool color, but there's a warm blue—cerulean blue—that has more yellow in it, and a cool blue—French ultramarine blue—that contains more purple. But your understanding of all this will come in time. Let us now discuss the colors I do use in more detail.

Cadmium red light. This is the warmest of the reds, even warmer than vermilion. Try mixing it with cerulean blue and see what fine grays result because both colors contain yellow, the third primary, whether you realize it or not. And all three primaries mixed together neutralize each other. Keep in mind that most reds, including this one, go colder with the addition of white.

Cadmium red deep. I use this when I need a darker, colder red but don't want it to be as cold as alizarin crimson. This is not a clean color, so when I wish to cool and darken cadmium red light, yet keep it brilliant and clean, I don't use this. Instead I bypass it for a still cooler red, alizarin crimson.

Alizarin crimson. This is the coldest of the reds, and borders on the purple. It makes a rich purple when mixed with French ultramarine blue, which also borders on the purple. Experiment with it in other mixtures—see what happens when you mix it with greens, and try it as part of the three-color balance with blues and yellow earths (e.g., Naples yellow or yellow ochre) in skies, particularly in cloud shadows.

Cadmium yellow pale. This is the coldest of the yellows—even more so than cadmium yellow light. It's as cold as zinc yellow and is more permanent, I'm told. This is used in mixing greens where there's absolutely no breath of red wanted.

Cadmium yellow deep. This is the warmest of the yellows, and having it makes it unnecessary to have orange on my palette. This color is used to make cadmium red light even hotter and is used in mixing greens to get a hint of warm red with the yellow.

Permanent green light. Although some purists prefer to mix all their greens, I find this an exceedingly helpful color. This green has a lot of yellow in it and is indispensable for summer landscapes, although I seldom use it by itself.

Viridian. This is my dark, cool green—try mixing it with white and see how close it comes to cerulean blue. However, it's still not dark enough for some summer greens, and has to be mixed with alizarin crimson, burnt umber, or French ultramarine blue to darken it.

Cerulean blue. This is the warmest of my blues and is great when I don't want a blue that contains red. It's also good for intermixing to make neutrals. I certainly wish the manufacturers would find a way to make it more lush and pliable, though. It's always so thick in the tube, especially since I prefer to work without medium. (Many artists consider this a cool blue because it contains green, but I see it as warmer blue because is has more yellow in it than ultramarine blue, which leans toward the cooler violet shades.)

French ultramarine blue. This is a deep, rich, red blue. It's a versatile color that's used in many deep mixtures, yet used with sufficient white, it can play a vital part in painting skies and clouds. Mixed with alizarin crimson, it will make a tremendously rich dark—better than black. (If this dark goes too purple, add some raw sienna to neutralize it.)

Payne's gray. This mixture is roughly half black and half French ultramarine blue. I seldom use it as a gray, preferring to mix my own, but it has the qualities found in French ultramarine blue, though not as clean. I find that I use it most in formal portraits, when painting the usual "dark suit."

Black. Some painters use black with great success, although I prefer not to. I feel it's absolutely taboo for students, for they'll tend to use it every time they wish to darken a color. Therefore, I *don't* use black.

Earth colors. These I divide roughly into yellow earths and red earths. It may help to remember that reddish earths are referred to as "burnt."

Naples yellow, yellow ochre, and raw sienna are basically different values of the same color. I use them strategically when I wish to add a yellow earth and at the same time either lighten or darken the mixture.

Burnt sienna is a lovely warm red color. When you first experiment with mixing colors, I suggest that you try combining this and French ultramarine blue to make grays, for burnt sienna is basically a combination of red and yellow. Depending upon which of the two colors dominates the mixture, the result is either a warm gray or a cool gray. Then, by adding varying amounts of white to it, you can control the value. This combination has a vast range of uses, from dark tree trunks to the delicate grays of cloud shadows.

Flesh. At first, it sounds strange for a landscape painter to include flesh on his palette. In fact, it's even frowned upon in many circles to have it included in a portrait painter's palette. But, if you just disregard its misleading name, and think of it as white with a small

amount of red in it, it becomes a very useful color, rather in the same category as Naples yellow, which is white with yellow in it. When you have to mix white with green, for instance, and it needs neutralizing, flesh is very handy. It's also very useful in painting skies.

White. Instead of just plain white, I use one of the better mixtures, such as Superba or Permalba white. These contain mixtures of two or more basic whites—zinc, lead, and titanium—and this combination, the chemists tell us, gives us the desirable qualities of each.

Medium

My advice here is to use as little as possible. Most of the time I use none at all, but I break this rule occasionally if I run into a tube that's too thick or when it's very cold outdoors in winter. Otherwise, I like the thick, creamy, buttery feeling of paint used directly from the tube.

Varnish

When I attended classes years ago, I never heard a word about varnishes. But I find them a very necessary part of making a painting. I apply retouch varnish as I work because, as paint dries, it sinks into the canvas and changes color and value. Since my paintings are made over a period of days, when I start to paint, if any part of my canvas is not as glistening as the new paint on my palette, I bring it back to its original "wet" strength by the application of retouch varnish. If the painting is at all wet, then the varnish must be sprayed on; but, if it's dry, it can be brushed on. Be sure that only a *retouch* varnish is used at this stage, since varnish used between the layers of paint must not be too heavy.

When the painting is finished, and after it's completely dry, I apply damar varnish to protect the surface. But I may have to wait six to twelve months after the painting is completed, before this can be done. The waiting time depends on the thickness of the paint. The heavier the impasto, the longer it takes to dry thoroughly.

Using the Full Palette

I think this is a good place to make the following observation. Often, through inexperience in mixing colors, students end the day with certain colors untouched on their palettes. Remembering this, the next time they lay out their palette, they put out fewer colors. But this becomes a vicious cycle, for if certain colors are never there, then students never learn to use them. Now, being of Scot ancestry, I don't like to waste material. But in learning to use color, you're bound to waste a certain amount, and if a color isn't readily available, you're not going to try to use it. So, in order to learn to use these colors, you must lay out your full palette of colors before you start painting.

The Starved Palette

While we're discussing the subject of pigment on the palette, I'd like to comment on another shortcoming. Many students work with a "starved palette"—that is, they just don't squeeze out enough paint. Many times I'll remark to students that I *inhale* as much paint as they've squeezed out! You must learn the joy of using enough paint so that the surface of your painting has a patina of pigment as you work one color into or over another. Also, if I don't see lovely color mixtures on students' palettes, I'm quite sure that I'll never see them on their paintings.

Notes on Color

I don't know whether you've ever thought of it, but there are actually only three colors needed to make a painting—red, yellow, and blue. All the rest make painting easier, but aren't actually necessary. These three colors are called the "primary colors," because you can't get them by mixing any other colors, yet they can mix every other color. When you set up your palette you need enough colors to be practical and helpful, but not so many that you don't need to inter-mix them. Intermixing colors makes for fascinating variations and harmonies.

How to Mix Colors

Students always ask how I mix a particular color, and I usually reply that this isn't like a paint store where you can mix a color by formula, with a quart of this and so many ounces of that. As artists, you must be able to determine the mixture by careful analysis. This is one of the hardest parts of learning to paint because it's difficult to be specific about how to mix colors—it has to be felt and sensed. Most of the time, I mix my colors on the palette automatically, like someone composing music at the piano, where the tune is in his mind and his hands run across the keys to produce the sounds he wants. You may find this hard to understand now, but someday I hope you'll be doing this, too. Then you can concentrate on *what* you are saying, because the *doing* will be almost automatic.

To explain this point in my classes, I often use the analogy of a musician playing a violin. If a piano note is struck, his ear would tell him where to place his finger on the neck of the violin in order to create the same note. As an artist, you must do the same thing with your eyes. Through observation, analysis, and practice, you'll learn to see the composition of the color, and then you can select and mix the right colors on your palette. Of course this is quite complicated, since most times you're not dealing with just a single color but with a composite, like a chord struck on a piano. Your eye must be able to tell you just what colors are in the mixture, as a musician is able to define with his ears just what notes are in the chord.

In general, to mix colors, you must work mostly in one of two directions. If you try to get the most brilliant, pure, vibrant color, you should keep the complements out of the mixture. If you're after a gray, muted effect, the opposite color should be purposely introduced. As one of my teachers, who was not known for being overly complimentary to students, once told me, "Well, at least you know what to do if it goes too green." One good rule to remember is, if the color in a passage is hard to define, that is, if it's neither a definite primary or secondary color, but one that's hard to categorize, you'll usually find that it's made up of all three primary colors.

Analyzing the Color Correctly

I'm always saying that painting is a process of analyzing and synthesizing—you *must* be able to predetermine *what* you want as the first step to achieve it. I can't stress this too much. Many times, when students claim they can't "get" a certain color, I look at their paintings and find that very color somewhere else on their canvases. Their greatest problem is not that they can't *mix* the color, but that they can't decide exactly what color is needed because they haven't analyzed correctly the colors they see in the subject.

If you have this problem, too, I suggest taking a negative approach. That is, you may not know *what* color you *want* and how to get it, but it's not too difficult to know what you *don't want*. In other words, as soon as you have a few brushstrokes in a certain area, you have to analyze right then and there if it's really the color you want in that area, just as a violinist does when tuning his violin. If he plucks a string and it doesn't sound the same as the note struck on the piano, his ear tells him immediately that it's wrong and whether it should be adjusted up or down the scale. You must learn to get the same information with your eyes.

I josh my students by telling them that all they have to do is mix the correct color and value and put it in the right place. I make it sound easy—but it usually takes many years to become proficient at it. Even professional painters don't mix the correct color and value every time, but as soon as the mixture goes next to the other colors, they know if it's right or wrong. If it's right they continue to use it, but if it needs adjusting, they immediately do just that. I stress this, because for years I've seen students continue to paint a whole passage in what is obviously the wrong color and value. When I ask them why they do it, they say they just wanted to get something down. "Something" is not what you want; it must be as close to the desired

finished effect as possible or you're merely getting "arm exercise."

Speaking of getting the actual paints and pigments, in the keys to follow I'll give you some notes on some of the colors I used in certain passages. I may or may not always mention the presence of white, but you should be experienced enough to realize that whether or not it was used depends on how much the color is tinted.

Color and Light

Let's delve further into color and its use and reflect on just why we see color. When I tell students that the reason they see green leaves is that the leaves happen to have a chemical substance that absorbs the color red, they show disbelief, unless they're familiar with basic optics and physics. For color does not exist as we normally think of it—trees are really not green or skies blue. Each simply reflects rays of light that vibrate at a given rate of speed. Those rays, bouncing into the retina of the human eye, produce sensations that we refer to as "color." When these sensory nerves of the retina are in short supply, as in color-blind people, nature appears as a more monotonous gray. The back of the human eye, which might be compared to the film section of a camera, is made up of rods and cones. The rods are sensitive to values and the cones to color. Let's hope you were endowed with a more than average share of cones!

Light rays fall upon all objects, whether they be trees, apples, or flesh. As you probably know, a single ray of light contains all the colors of the spectrum. Newton showed us this when he broke up a light ray by passing it through a prism. Part of the color is absorbed, as I told you before, and the rest is reflected off the object, the amount of reflection being governed by the texture of the object's surface. Now, the light ray bouncing off a surface also picks up some of the local color of that surface and deposits it on the object it reflects into. For example, sunlight reflecting off a green pasture onto the underside of a cow's stomach will make that animal's stomach look slightly green.

In all my painting, both indoors and out, I'm obsessed with what I call "the drama of light." The only reason that you see anything at all is because there's some form of light present, and the effect of the light falling on objects enables you to see color and creates gradations of value.

Seeing and Exploiting Color

Seeing color is partially physical and partially emotional. Most students have to be made more observant of color, for they tend to see in a monotone, or they see what they "think." I've spent hours discussing the fact that your analytical perception is dominated by what you *think* you see. And what students think they see is what they paint! A classic example of this is that most beginners will paint skies blue, trees green, and tree trunks brown—they have to be taught to see beyond what they *think* is the solution.

I enjoy the lush use of color. For me, every object offers an excuse to use it—and exploit it to the hilt, though I'm careful not to make it garish.

Just as most novices don't use enough color, they also don't provide enough contrast in their paintings. It takes years of painting experience to stand about two feet from a canvas and be daring enough to use color so boldly that it will withstand the subduing effect of distance. That's why, in this more advanced book, I'm taking you in for a closer look at sections of my work. When I go to a museum, I delight in studying how brilliantly small passages of certain paintings are handled. Many times, these seemingly insignificant passages are a great indication as to the accomplishment of the artist.

The Influence of the Impressionists

One of the most scathing comments one of my own great instructors used in referring to some painters was, "He paints as if the Impressionists never existed." The Impressionists and their followers made some of the greatest contributions to the advancement of painting, and the use of color in particular, since the Renaissance. Previously, landscape work had been done mostly in the studio, and so artists were used to the cool lights and warm shadows that prevailed in this type of painting. Before the Impressionists moved outdoors, artists painted landscapes in which the trees and hills bore no relationship to the skies above them, and they used bleak colors that lacked the bright contrasts and fresh tones of the real landscape.

Outdoor painting really started in England, when Constable and his cronies started taking their easels out into the open. This movement spread to the Continent where young Frenchmen like Delacroix, tired of the hide-bound conventions exemplified by the work of David and his group, eagerly went out into the fields to paint. From this was born the great Barbizon School, which was the forerunner of the Impressionists, who have so influenced our present way of thinking.

The big difference between the old indoor and the new outdoor approach to painting is the complete reversal of the warms and cools. Going outdoors, the artist found that everything that the sun's rays shone on was warm in color, and the shadows being illuminated from the blue sky above were really cool. At the risk of being called repetitious, having already told this story in my previous book, I have a charming way of remembering this point. Years ago, a wonderful, old Italian painter by the name of Nunzio Vayana told me in his delightful Italian accent, "The sun is like the woman. When the woman kiss you, she leaves the little lip rouge on your face. When the sun kisses the earth, it also leaves the lip rouge and everything is warm where she touches." Ever since then, I've had no

trouble remembering that sunlight in a painting should be made warm.

I personally feel, in the Impressionists' attempts to explore this great new world of color, that many times solid drawing and good values suffered in some of their work. That is why I try to include these elements *along with* color. While color is my primary concern in this book, value is so important that, to the beginner, I suggest that if it's a toss-up between getting the correct value or the right color, he should concentrate on getting the value first.

These are a few of my thoughts on color in general. Although only years of experience will enable you to really use color the way you'd wish, I hope that this discussion will help get you started. I also want you to keep in mind that I've only been dealing here with the *mechanics* of painting, and not the emotions and feelings that also go into the making of a painting.

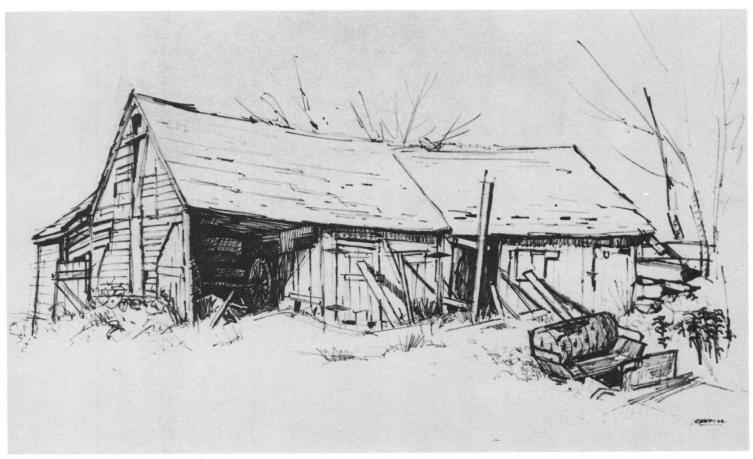

BARNS AT THE BUTTON FARM, *felt pen on toned paper, 15" x 23" (38 x 58 cm).*

Although this book is primarily on *color* in landscape painting, I can't overemphasize the importance of drawing. I compare drawing to spelling or grammar in writing a novel—when you can do it well, it frees you to concentrate on the story. Thus, in order to concentrate on color and the more aesthetic phases of picture making, you must be able to draw well and automatically. You can learn to draw and develop it if you're persistent and practice. Don't be like many amateurs who are so busy making pictures that they can't go back and develop the basics that will enable them to make the finished product better.

Painting Procedures

This is one of my favorite subjects. It's a typical scene of the many small mills that were built on our New England streams. Initially they served many purposes, such as grinding the local corn and flour, or cutting boards from local lumber. But unfortunately, today they're fast disappearing, for our highly urbanized society finds little use for them, except as a reminder of our wonderful past and as an excellent subject for artists and photographers.

The effect I was after was that of a bright sunny morning after a recent snowfall. I chose a time of minimal light patterns for a more sparkling, sunny effect. However, I do want to stress one important fact: here, as in all my paintings, I could see the final painting in my mind's eye before I even started. I knew exactly what I was after and how I was going to achieve it—and that's what I hope to help you with in this book.

Basically, this comes from knowledge and experience. I often compare the amateur painter to a person who gets into a car and starts driving without knowing exactly where he's going or how he'll get there. The professional knows what he's after and has a plan established in his head of exactly how to achieve it. Every brushstroke either helps the painting or hurts it. So many students say, "Oh, I'm just getting something on there." Believe me, *something* is not what you need. Instead, each stroke must absolutely be a contributing step toward the beautiful end result.

I'm going to take you along on a step-by-step demonstration of how this painting was actually made. I wish you could have been watching over my shoulder, as my own students do, but I shall do the best job possible with the printed page. I took the photographs that you see after each step—they weren't improvised later. And I used the same procedure here that I used in the rest of the paintings in this book. You'll notice, however, that working outdoors doesn't lend itself to much fussy detail.

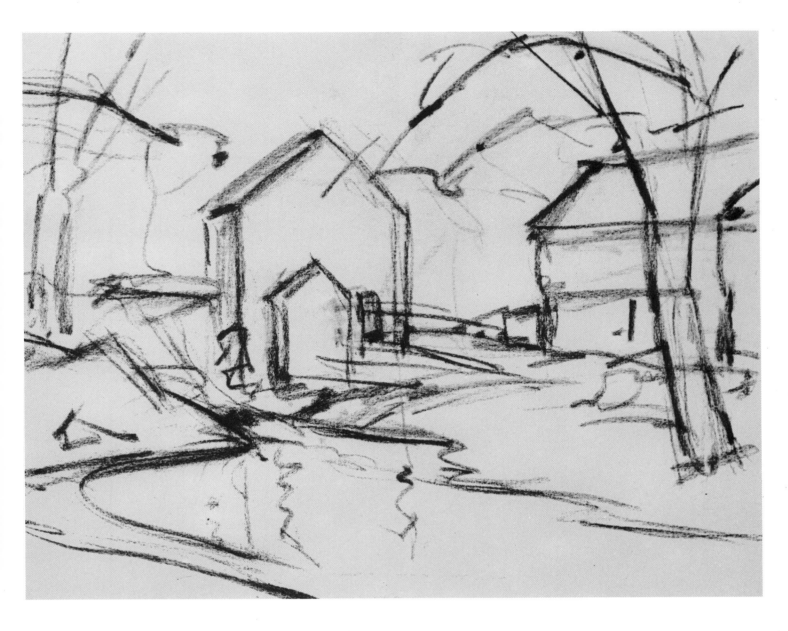

Step One. The start of this painting looks casual and sketchy, but it contains some of the most important thinking involved in the making of any painting—namely, the overall design and composition. In their enthusiasm to start painting, many students get off to a bad start by ignoring the importance of the big design. So, unless you resort to major surgery, you'll be stuck with the decisions you make now throughout the entire canvas. And even when changes are needed, your painting may be so far along by then that you may hesitate tearing it apart in order to try and improve it.

I always stress the importance of drawing well, but don't confuse this with drawing in great detail. A painting is not a carefully drawn map that's "colored in," but a beautifully designed, freely executed conception that gradually takes on the desired amount of

detail in the final stages, after all the big problems have been resolved.

I make my first design with soft charcoal, as you see here, because it can be dusted off and changed easily if necessary. When it looks as if I'm on the right track, I dust it down, leaving a ghost image visible, and reconstruct it in paint with a light earth color like yellow ochre. I use a relatively light color at this stage because, if I want to change it later, I can easily paint right over the initial drawing with a darker color, such as burnt sienna, without taking it off first with turpentine. I strongly advocate an orderly process of developing a painting so that your mistakes are caught before you're so deeply involved that to make changes seems overwhelming. I have carried the charcoal design a bit further with paint, but in no way could this be considered a detailed drawing.

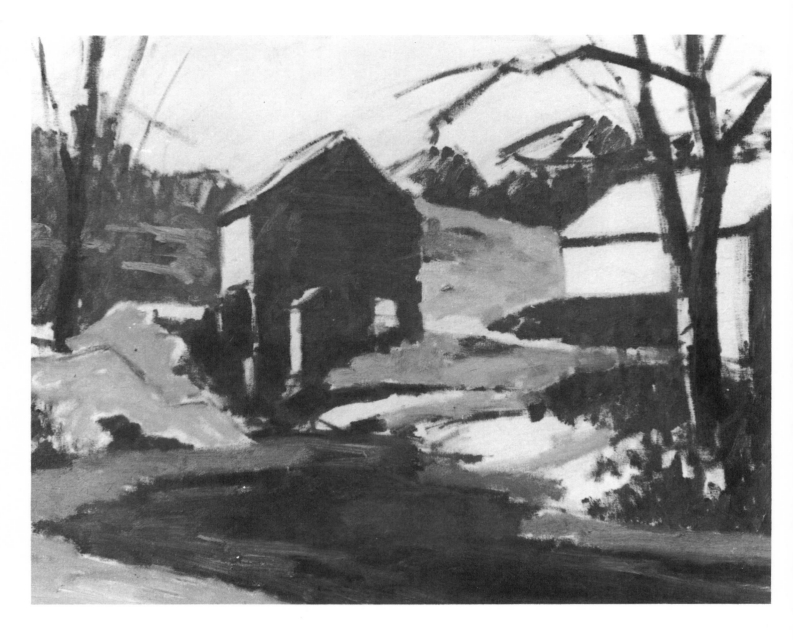

Step Two. Now that the design is complete, I begin covering the canvas with colors and values. The most common mistake students make now is to begin painting the light areas, although many times the lights are the more interesting passages of a painting. In this case, a student might find it more logical to paint the sky in first so the tree can be painted over it—but notice how I actually do the opposite. Why? Because it's virtually impossible to paint a light color on a bare white canvas, and judge its color and value correctly. Since the white canvas represents the lightest light possible to achieve, you must first start by painting the darkest darks. By doing this, you establish the extreme limits of the value scale against which the rest of the values can be compared.

Here I start by painting the darks around the stone foundation of the old mill, using a combination of my three primary colors in their deepest state—namely, French ultramarine blue and alizarin crimson, with some raw sienna to partially neutralize the other two colors and prevent them from becoming too purplish.

I then place darks in the water, trunks of the trees, and open underneath section of the barn on the right—but here the value becomes a step lighter because it's a bit farther back.

Next I add the purplish underpainting of the bare trees atop the hill in the distance with French ultramarine blue and alizarin crimson, using Naples yellow to lighten it. Essentially, I use the same basic combination, but now I deepen the yellow to yellow ochre and raw sienna and let the beautiful alizarin crimson dominate the mixture, as I lay in the colorful weeds and bushes in the lower right-hand corner. (I'll discuss the colors I used in passages like this later in the key accompanying the painting *December Drama*, on page 55.) Now, I'm ready to begin painting areas of snow in shadow, as I move a step up the value scale toward middle value. In these passages, I try to see how interesting I can make cerulean blue, modifying it with hints of reds and earth yellows rather than leaving it just plain blue.

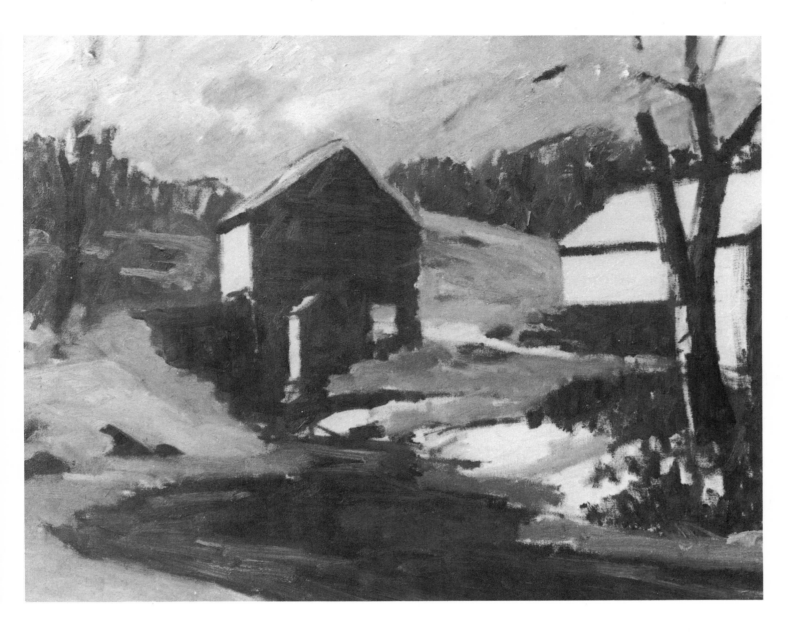

Step Three. The important thing you should notice now is the absence of any paint on the canvas in the lightest passages. Because of this, see what a feeling of sunlight exists in this painting already—and it's just getting underway. These light sunlit passages are not something that are added later. They should be in your painting from the very beginning, as bare canvas. This bears out my admonition that light passages are seldom painted correctly if they're introduced into the painting too early.

In this step, I'm dealing mostly with middle values. The most important passage now is the sky. As you can see, I'm gradually working up to the lightest lights, and only now do I feel that I have enough other passages on the canvas to tackle the sky intelligently. Before I begin, I decide how the sky section has to relate to the painting as a whole. I know that it has to feel like the sunny day I'm painting, yet not be so light that it rivals the eventual highlights I plan to paint in the snow. I decide to design it so that there's a definite

feeling of a strong sun shining off to the left, outside the picture. I do this by painting the sky so that mostly darker values are on the right, the side opposite the sun. Also I have to make sure that there's a good middletone next to the snow-covered, sunlit roof in the center of the painting. As you can see, I'm really painting an abstract design that accomplishes all these things and yet looks like a realistic sky.

I make the cloud shadows a purplish gray of cerulean blue, alizarin crimson, and a hint of warm yellow earth. The sky is painted cerulean blue and white, and the sunlit clouds have flesh and Naples yellow in them, which warms their color and reduces their value so that they don't rival the light-colored snow.

This is no time to worry about covering the branches of the trees with sky color. Many times, such worry results in an inconsistency of color and values in various sections. So I boldly paint the sky over most of the tree, since it's much easier to repaint them later when the sky dries, rather than fuss over them now.

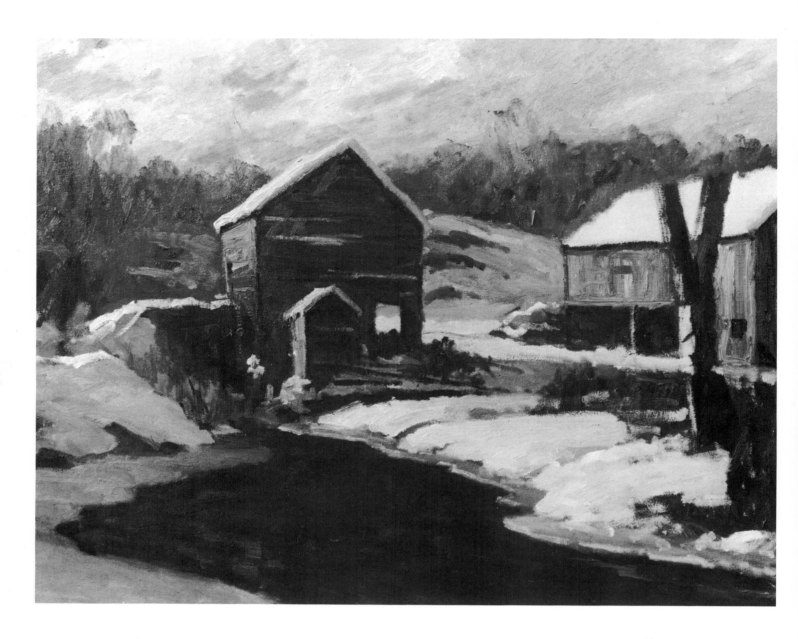

Step Four. Now, as I add detail in this stage, I can gradually begin to refine the painting. The discrete lights on top of the snow bank on the left that were too small to save as white canvas are now indicated—notice the attention I paid to drawing in the way I applied the paint here. There's warm color in these lights—nowhere is the snow just plain white. I repaint the large dark areas, such as the shadow side of the old mill, with more thought to refinement and detail—raw sienna plays an important part in this section. Notice the indications of snow clinging in places to the old board siding. Being in shadow, this is painted a purplish blue. I also spend time suggesting the pile of old timbers covered with snow in the shadows in front of the mill. I'm thinking of color and design as I superimpose the weeds and brush into and over snow passages with red and yellow earth colors. In the distant hill between the two buildings, I casually indicate brush and large outcroppings of fieldstones.

Only now do I indulge in some of the secondary passages that a novice might have tackled much sooner. Note how I have one "star," so to speak—all the other passages play a respectful secondary role. The sun hitting on the side of the old mill deserves, and gets, our prime consideration. Notice how the residue of the building's original paint is much stronger under the overhang of the roof—here, I went all out with a combination of Naples yellow and cadmium yellow deep. But further down, where the building is more weathered, I use raw sienna and permanent green light. The barn on the right shows the effects of a much weathered yellow earth paint—I avoid converting the old buildings to the typical red seen on so many Christmas card paintings. I now develop the light areas of snow in the foreground. The snow is basically bluish where it faces the sky, but where it faces the sun at a forty-five degree angle, its color becomes brightest and warmest.

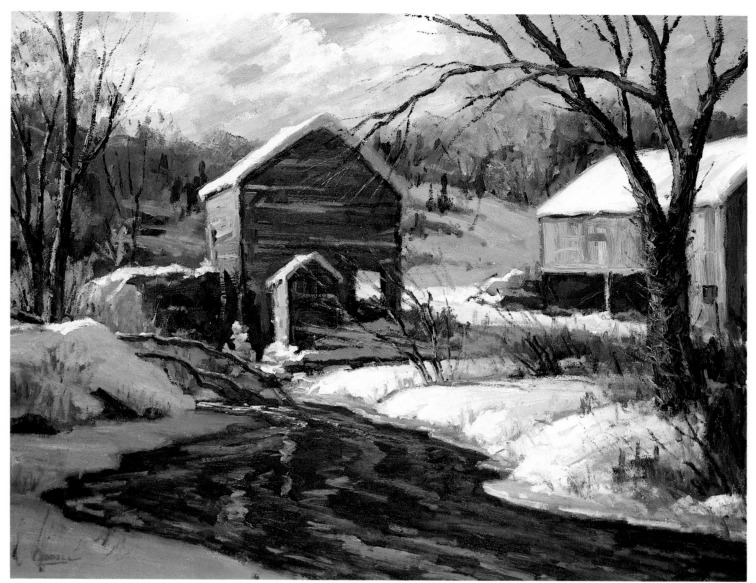

THE LEWIS MILL, *oil on canvas, 24" x 30" (61 x 76 cm).*

Step Five. Certain details can best be added when you're not fighting a lot of wet paint underneath. For example, now that the sky is dry, the tree branches are easily indicated. Notice how they're designed so that they sweep the viewer's eye from the upper right-hand corner back to the center of interest. Into their basic dark value of burnt umber, I paint variations of greens and blue-grays to indicate moss on the branches and the cool colors of the sky reflecting into shadow sections.

On the distant hill, I indicate the lovely warm colors that we find when the sun hits the dried oak leaves that tenaciously cling to the trees over the winter. To complement these warm oranges, I take advantage of the presence of a few evergreen cedars and pines in the scene in order to flick a few greens into this general area of bare trees. At this time of the year, you can find beautiful colors in the dried-up grasses and weeds that protrude through the snow banks on both

sides of the painting. By going to nature to paint, you can observe bits of detail, such as the clinging old poison ivy vine growing up the trunk of the tree on the right, that you could never imagine sitting indoors.

At this point, I add interesting color found in the flowing stream—reflections of the warm highlights from the old mill and blues from the sky above. And, because the underpaint is dry now, I can easily add the old dead tree that has fallen across the stream, and the few flickering highlighted ripples of the stream as it comes around the bend of the snowbank.

Notice how much detail is *not* in this painting. The secret is to include just enough so that the viewer thinks he sees more than you have actually put in. Now study the finished painting carefully. See if you can "read" it with your eyes. Go over small sections of it, and try to understand just *what* I did *where* so that your knowledge increases and you'll be able to tackle a similar project on your own.

23

Painting the Cool Colors of Shadows

Problem

The danger in painting a scene such as this one is to be so concerned with painting details on individual items that you forget to look at the scene as a whole and fail to see the way the light falling on objects affects their colors and notice the many cool colors present in shadows. Also, because of this over-concern with recording facts and details, you may forget to embellish it further with a bit of poetic and artistic charm. Not being able to *really see* colors is one of the major handicaps of the novice painter, who may see the shadows on a white house as still "white," and the shadows of trees falling across a road as just a darker "dirt" color. Few students would have painted the shadow side of the white cottage in this painting darker and colder than the grass in front of it, but that is the way it actually appeared. As soon as you begin to realize that the presence—or absence—of direct light on an object is as important as what that item actually is, you'll have made a giant step toward successful landscape painting.

Solution

There's a simple, logical, and scientific reason why shadows in a landscape are cool. There are two sources of light in nature. The main one, from the sun, is naturally warm in color, but the second source is the subtle cool light that filters down from the sky above and illuminates shadow areas. By simply painting cool shadows in one area of a painting, you can make your sunny highlights appear even warmer by comparison or relativity.

If I can impress you with one main thought here, it's that, as you paint any object and are determining its color and value, the first question you must ask is, "Does direct light fall on it?" With this single clue, you now have the main answer to achieving the effect of sunshine in your paintings.

Handling Backlight in Autumn Trees

Problem

Backlight in a painting gives a marvelous effect if it's handled correctly. As in many other areas, the amateur is handicapped by his inability to analyze a scene critically. This seems especially difficult in the autumn, because of the profusion of colors then that seems to make it more difficult to see values accurately. The critical decisions are to be made in the shadow passages of the foliage. If they're painted too light, it diminishes the effect of light in the highlights. If they're painted too dark, they have a dull heavy look instead of brilliant luminosity. The delicate balance that's necessary takes years of experience and knowledge.

Solution

Since much of the effect of brilliance in a painting comes from contrast, you must remember to give careful consideration to the areas *adjacent* to the lights. If the shadow passages of the foliage are dark enough, the viewer will get the impression that the highlights sparkle. Here, the deeper blue passages on the white house do much to enhance the sensation of sparkling light in the trees.

Sunlight coming *through* leaves gives us the greatest sense of color at its most intense, especially with autumn foliage. To make the shadow passages appear luminous under such conditions, it's helpful to have still greater darks adjacent to them—such as the tree trunk, in this instance.

Bad
In this sketch you can see that the thinking is dominated by the color objects are named (that is, their local color) rather than by correctly observing the effect that the light has upon these colors. Because of this, the shadow side of the white house was painted a flat, ordinary gray and is far too light. Also, too much attention has been paid to details in the windows and not enough to the general quality of color.

In painting roads, many students paint the shadow areas the rather pitiful dirt color of raw sienna and render the skies "blue" no matter what their true color or without a thought as to how these colors could be improved.

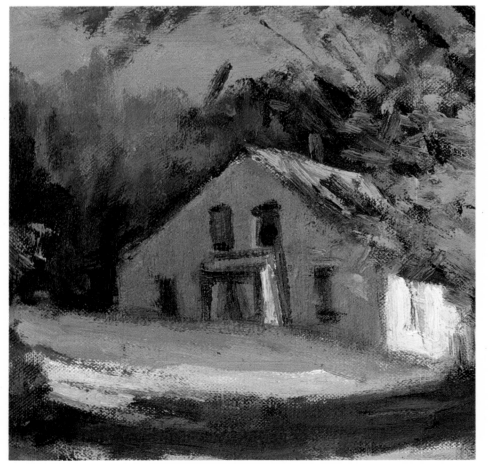

Good
Now you can see how I exploit the colors in cool shadows in greater detail. I usually paint shadows like the ones here a little too blue first, and then introduce other colors into them while they are still wet. Notice how the green of the grass, plus a bit of alizarin crimson from the sky, reflects into the shadow side of the house.

In treating road shadows, I usually start my general underpainting too cool by using blues and purples. Then, while it's still wet, I introduce variations of warm colors into it. Here, for instance, we find warm, burnt sienna leaves scattered about the edges of the road, and hints of grass growing in less worn sections.

Bad
Because the leaves on the near, or shadow, side are painted much too light, the tree appears flat, and the light coming through the leaves on the far side has lost its impact. The timid attempt to paint the house behind in shadow has failed to exploit the tonality that would make the leaves in front of it sparkle. Also, for some unexplainable reason, students seem to paint tree trunks brown.

Good
Notice that the shadow side of the tree, which is now sufficiently deep, has warm yellows and oranges painted into the basic green to achieve the color quality of leaves when they first start to turn color. The shadow side of the house behind them is a deeper blue, with hints of the alizarin crimson that occurs in the sky painted into it.

I make some of the highlight brushstrokes in the tree as clean and brilliant as I can get them by using cadmium yellow light and cadmium yellow deep right off the palette. All this results in the final effect of a sparkling backlight.

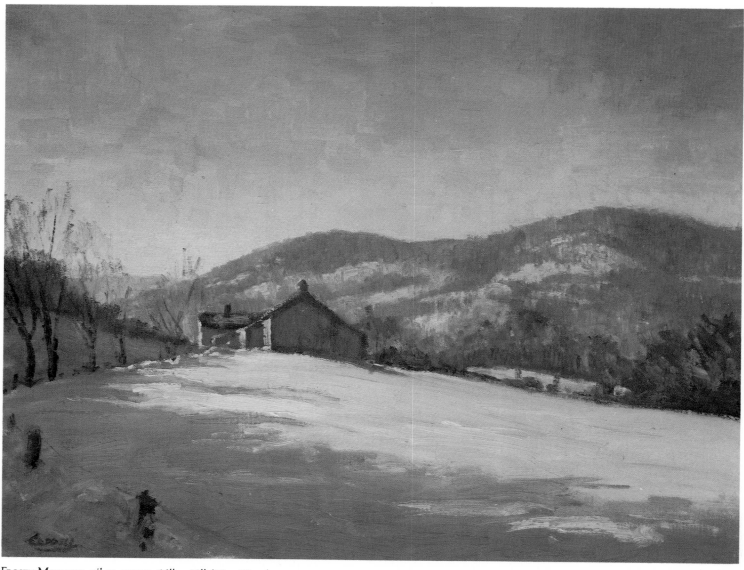

FROSTY MORNING, *oil on canvas, 16" x 20" (41 x 51 cm).*

In this book, I'm giving you a cross section of the seasons and conditions, and how color plays such an important part in portraying them. Since painting is a means of communicating, I wanted the viewer to sense the still, cold, crisp atmosphere of this particular winter morning. *I* know it was cold then—it was actually ten degrees—but the challenge was to show *the viewer* that it was. My paintings are basically warm, but this subject, with blue predominating, is a symphony of cold colors. In the keys for this painting, I will demonstrate how to set a mood and feeling of coldness in a painting, and how to find beautiful variations in color in a subject matter as limited in color as this one.

Creating a Definite Mood and Feeling With Color

Problem

The basic problem here is to capture the cold, crisp atmosphere of this winter morning. I feel that many of you fail on a subject such as this because you don't go out and paint directly from nature. Instead, you try to paint from imagination without first-hand observation, or by copying color transparencies—I never do either.

Another problem you should immediately recognize here is that the subject matter is well back in the middle distance, so there are no real darks. Yet, in spite of this, you must achieve the feeling of crisp sunshine.

But the greatest challenge here is to achieve the delicate balance of the subtle warm colors of the morning sun as they begin to flow over the predominantly blue landscape.

Solution

The main solution, as far as I'm concerned, is, of course, going out to nature and keenly observing first hand what you're trying to capture. The fact that the vast expanse of sky was a simple progression from the warmth of the early morning sun, through the subtle gradation of green and blues, to finally the deeper ultramarine blue, helped me create the mood of cold stillness. To add to the *coldness*, I took the artistic liberty of imagining the hill, out of the picture to our left, as being higher than it actually was. By doing this, I was able to cast a much larger portion of the foreground field in cold blue shadow.

In a painting like this, you must be sure to maintain sufficient value differences between the spatial planes to create the illusion of distance. See how I achieved this on the left side of the painting even though I was working with limited values.

One word of caution: because of the low temperature on location, you'll have to paint with gloves, which isn't conducive to detail. Resist the temptation to fuss with the painting too much when you get back in the studio or you'll tend to lose the fresh spontaneity you have.

Finding Color Even When It's Limited

Problem

The main problem here is to paint a predominately blue painting, yet introduce subtle variations of color into it. The problem is compounded by the fact that students tend to paint the colors they know objects to be, instead of the colors they really are. And most beginners, I'm afraid, think of skies as just plain blue. Since their color perceptions are undeveloped, they usually sense a color only when it's very obvious—and then tend to overdo it—or overlook it when it's extremely delicate. (I tell my students they must learn to whisper as well as shout.) Another difficulty is that early morning effects such as this one change rapidly. If you're unable to remember them, and paint from that memory, you'll be dominated by the more ordinary lighting conditions that occur later in the day. One sure thing is that if you don't go out and paint nature first hand, you'll have no visual goal of what you're after.

Solution

In the previous key, I described how I painted a progression of color and values in the sky. The secret, as I've said, is to exploit every possibility of color variation that exists and to paint not what you "know," but what you see. The trees on the distant hill have a little warmth in the sections that catch a bit of the early morning sun. Notice that even the snow areas here are not just plain white.

As we come closer to the tree area at the foot of the hills, you can see that it is made up of oak trees. Most oak leaves stay on all winter until the new leaves force them off, and thus provide warm colors if you search them out. A few nearby evergreens provide another color variation to complement the oak leaves. Notice that because of the distance, no dark is very dark. The snow-covered field contains subtle variations of color, with warm reds and yellows in the lights and cold reds in the shadows.

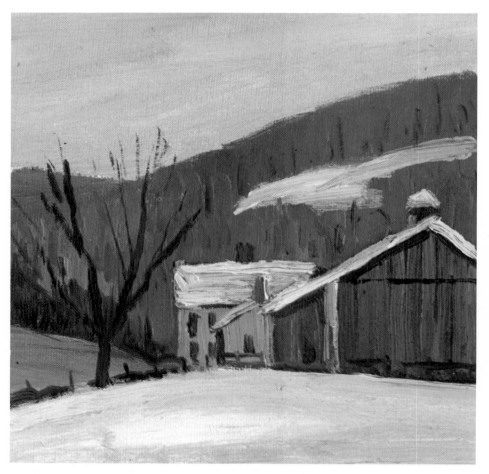

Bad

Here the painting lacks the color quality that gives us that cold, frosty feeling. The colors lean too much to the umberish grays rather than the lovely soft blues, and the distant hills on the left lack the delicacy of value and color that will push them back.

This is more a record of the place than a feeling of a mood and condition of nature. The novice often is concerned with statistics and facts, as you see here, rather than letting the viewer's imagination supply them.

Good

This is primarily a study in cool blues, with French ultramarine blue predominating. Notice that passages of alizarin crimson have been introduced while the underpaint is wet. The warm colors in the sky are ever so delicate. Starting with Naples yellow, and cadmium red light with white, they progress upward into viridian green, cerulean blue, and finally French ultramarine blue, in the sky at the top of the painting. Notice that I've added a delicate hint of warmth in the foreground field—a touch of cadmium red light and Naples yellow. But it must be subtle to be effective. Under these lighting conditions, the old weathered barn becomes a beautiful variation of blues—even though we know it's really old weathered grays.

Bad

Here, we lack the color quality that defines the mood of the scene. The handling and use of color lack all the subtle nuances that you find in the good example below. Instead, the preconceived idea that skies are "blue" and trees are umberish brown and gray predominates. There is no modeling of the hills—either in the trees or snow sections—to indicate the *form* created by the sun striking some portions and not others. Instead, time and effort was wrongly spent explaining that there was a stone wall in the foreground. The result is that the viewer is attracted to the unimportant detail instead of the beautiful overall color quality and atmospheric effect, the theme of the painting.

Good

I separated the nearby trees from the distant hills behind them by underpainting the trees a darker blue and adding warmer notes of alizarin crimson and raw sienna to it, and by keeping the base color on the hills a light blue. In the tree area on the distant hills that face the sun, I subtly introduced soft reds and yellows to suggest the presence of sunlight. However, the sunlight on the oak trees in the *foreground* gave me an excuse to use stronger warms—alizarin crimson and raw sienna—on their leaves, since they're closer. Notice the hint of permanent green light in the nearest hedgerow. It suggests some evergreens, gives us another subtle variation of color, and complements the adjacent reddish tones.

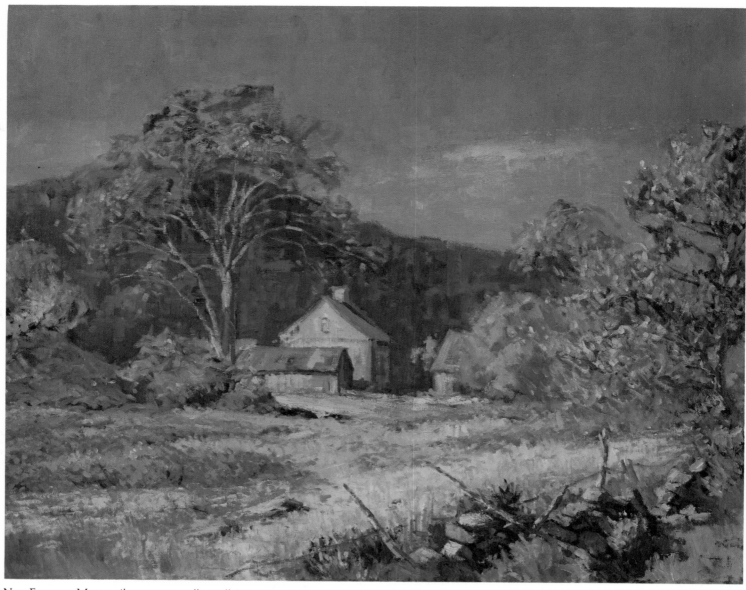

New England Motif, *oil on canvas, 24" x 30" (61 x 76 cm).*

As I stated in the Introduction, the Impressionists made one of the greatest contributions to painting by introducing scintillating colors and by doing a great deal of their mixing directly on the canvas rather than on the palette. I feel that my painting has been greatly influenced by their way of thinking, and I hope I can introduce you to this concept if you're not already aware of it. There are no absolute rules that I follow in mixing colors on the canvas. Sometimes I paint warms into cools, and sometimes I do just the opposite. Quite often I paint wet into wet, but other times I paint wet over dry. The only fact I can assure you of is that by experimenting yourself you can get effects that I sometimes call "controlled happy accidents." They're far more fascinating and interesting than if the very same colors were thoroughly mixed together ahead of time on the palette and applied in a single application.

You can see how frequently I superimpose colors and mix them together on my canvas rather than on the palette by studying the many details of my paintings, not only here, but throughout the book.

There are several points to keep in mind while superimposing your colors on the canvas. One is to select your center of interest and design your painting so that the colors in other areas of the painting don't compete equally for attention. The other is to be careful to superimpose different colors of *similar values* only, or the colors will jump out at you and won't appear to lie flat on the object. So while both these keys will discuss how to mix colors on your canvas by superimposing, the first will deal with the problems of design, and the second, with the problems of mixing the colors.

Organizing Colors into an Aesthetically Pleasing Composition

Problem

In this particular painting, one of the problems was to organize all the colors and patterns that existed at this scene and under these conditions. Everything seemed to be screaming for attention at first, and I had to selectively design and orchestrate the material into an aesthetically pleasing solution. Remember, it's what you do with the material on hand that counts. (The solution I used here is discussed in greater detail in my previous book where I comment on the strategic utilization of cloud shadows.)

Solution

Throughout this book, I refer many times to the principle of creating emphasis by holding down areas that might possibly detract from the center of interest. Here, the sky was so colorful and bright that it competed for attention with the brilliant autumn colors of the sunlit landscape. I resolved the problem by using artistic license. I assumed that the sun that illuminated the foreground and middle distance was coming through a break in the clouds, and that the sky was actually cloudy. This gave me an excuse to hold the sky color down with variations of grays. The same principle was applied in playing down the distant hill which, with full sunshine on it, rivaled the foreground for importance. I just painted it as though it were covered with a cloud shadow and, in doing so, provided some lovely darks to register against the buildings in the center of interest.

Mixing Colors on the Canvas by Superimposing Them

Problem

Most amateurs (and I did it as well) tend to overmix the color on their palette and apply the mixture in a solid sheet of color, in a manner referred to as "housepainting." It seems to be the most normal or natural way at first, and so students have to be shown the advantages of mixing some of the color directly on the canvas.

Here, even though I rendered the sky in many different colors, it ultimately had to appear rather smooth and, as such, almost a relief from the vibrancy of the rest of the painting. So I had to tone down my color mixture.

Painting the big elm tree also created a problem. Since it was illuminated by the sun, it had to have a feeling of light on it. This was no problem in the sections that were against the darker hill, but when it was seen against the sky, it had to register as a darker silhouette, too.

Solution

The way to keep the sky and tree in the proper place in the painting is to use the correct value when you superimpose colors. In the sky, each color has to be almost the same value as the others, except where the sky is actually lighter. The portion of the big elm tree seen against the sky is first laid in darker in value than the sky, then lighter colors are placed over them for highlights. But, where the tree registers against the hill, it appears much lighter than the background, and must be painted accordingly. In the bushes and lower trees in the rest of the painting, you should consistently lay in the darker values of each passage first, placing the lighter colors over them. In doing this, you'll achieve a great feeling of solid form as well as of wonderful color.

Bad
Here the pattern in the field is realized, but much too harshly. The green grass is painted just one green, and there are no variations of color in the red sumac. Grass, as it gets closer, should have a feeling of depth to it—here it's painted only with horizontal strokes. Also, for some reason, when students paint stone walls, they tend to repeat the same shapes and colors in all the stones. I often refer to this work as "dinosaur eggs." Look for these tendencies in your own paintings, for I find them in 90% of all student work that I see.

Good
Here the red sumac flows over the field in a soft pattern, the way it actually grows in nature. The nearby field was first painted with permanent green light, cadmium yellow pale, and white, then the warm grasses were superimposed with Naples yellow tinted with burnt sienna. Notice how the vertical application of the paint gives a feeling of depth. Also, to provide depth, I used strong contrasts and carefully delineated the foreground wall and bushes, but not enough to prevent the viewer's eye from traveling beyond them to the center of interest, further into the picture.

Bad
In this sketch, not only has no effort been made to superimpose colors one upon the other, but the values are too close to ever achieve the effect of scintillating sunshine. With the distant hill, as well as the foreground in sunlight, there should be strong contrasts of value and color between objects. Here, the delineation of buildings depends too much on outlines. Inexperienced art students, at first, see colors rather "plainly." To the uneducated eye, green is the same green all over, grays are made with black and white rather than by combining complements, and where a hillside is dominated by orange foliage, only crude simple introductions of other colors are added, as we see here.

Good
Study the color variations you can see in this small section. With poetic imagination, you can see and feel color in the weathered old boards. Over a basic cerulean blue, I painted variations of yellow and red. Quite often, when I feel the need of a constructive drawing line, I use cadmium red light, which suggests radiant sunshine reflecting off surface edges. The hill behind the house is basically French ultramarine blue and alizarin crimson, with permanent green light and raw sienna painted into it while wet. I painted the effect of sunshine on the grass first with a layer of permanent green light, lightened with cadmium yellow pale and white—then over it, I splashed cadmium yellow deep and white for the final warmth.

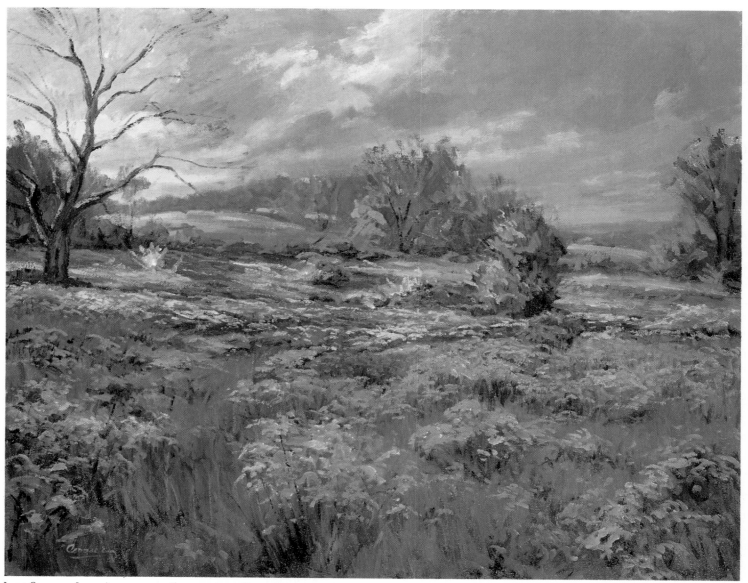

LATE SUMMER, LATE AFTERNOON, *oil on canvas, 24" x 30" (61 x 76 cm).*

For years, I've driven by this field on my way to shop in a nearby town. In late summer, just before the autumn foliage colors come along, this field becomes what I term "nature's oriental carpet." The colors of nature are always harmonious, and here, the wild New England asters in the foreground mingle with the goldenrod and joe-pye weed in the middle distance.

I always have many potential paintings in my mind, and this one took a long while to materialize. But, hav-

ing just agreed to do this book on color, I decided that the time had come to get over there and make this painting. I always stress the joy you realize when gradually the *how* of making a painting becomes easier, and *what* you're painting becomes the challenge. Paintings of this type aren't easy, but I hope the following information will help you with a similar subject.

Creating a Sky to Suit the Landscape

Problem

The problem here is to design a sky to complement or enhance your landscape. When you're painting in the studio and you want a certain background behind the still life, you hang the appropriate cloth up and paint it quite literally. But outdoors, Mother Nature is not as cooperative. So your ability, knowledge, and tasteful selection have to fill in the gap, because the sky in a painting must serve a definite purpose. Painting skies is one of the hardest things to conquer in landscape painting. This is because if it's difficult to paint what's *there*, it's practically impossible to paint what's *not there*—and even if the ideal sky *is* there, it's not for long.

Solution

To paint a sky such as this one, you must first analyze what is needed. When this much canvas is devoted to the sky, you must put some interesting pattern into it, without upstaging the landscape itself. Also, the colors you use must complement and harmonize with the landscape. To depict the time of late afternoon that I chose, I designed the sky so that the greatest amount of light areas are on the side that the sun is coming from. I also made the dominant flow of design of the cloud masses complement the angle of the hills. Having all this in my mind *before* I started, I then painted the sky. Although I'm grateful for any help I get from nature, most of the time you have to paint it from memory and theory, as I did here. This particular sky was painted in about half an hour—but, of course, that was after thirty-five years of experience and knowledge.

Finding Beautiful Colors in Wild Weeds

Problem

To paint a field of flowers, you must be able to organize shapes and colors into a dramatic design, which makes a subject such as this one very difficult. My wife, who was with me when I painted this, remarked, "How does the student possibly make any sense out of a field of flowers such as this?" The answer is that they usually don't. Without a feeling for mood and drama, and a great sense of design, a field of flowers often becomes a hodgepodge of colors and items. Several subjects in this book are of a similar type, devoid of solid, positive forms that are easier to structure. A critical decision in all paintings, but particularly in this one, is the time of day selected to depict the scene, and the choice of the ever-important play of light over the material at hand.

Solution

My first consideration in composing this painting was to organize it into a definite pattern and design. After I established the general design of the masses of flowers, I started to paint the green grass. Because, in many cases, the floral patterns were lacy, I found it better to paint the greens of the tall grass well into the floral areas first, and then paint the suggestion of individual flowers later. I concentrated on the dark earth colors that suggest the stalks of the flower masses at an early stage. I wanted to give a feeling of looking down *into* the grass in the foreground, as opposed to scanning across the tops of the masses into the distance beyond. With the foreground in shadow, I knew the dominant color of the flowers would be cool from the light of the sky above. Notice the variety of beautiful colors I managed to find every excuse to introduce.

Bad
Here the wrong blue—French ul-tramarine instead of the warmer ceru-lean blue—was used in the sky, mak-ing it too red. Also, the clouds are unimaginative in color; they've been executed in variations of Payne's gray and white and look like plaster of paris. The forms are also too hard, and the painting fails to achieve the soft feathery edges obtained by paint-ing wet into wet.

Good
After the basic design was estab-lished, I started painting the cloud shadows, primarily with cerulean blue plus a touch of alizarin crimson and white. Next, I indicated the patches of blue sky with cerulean blue. Only then did I begin work on the light passages in the clouds. Since it was late afternoon, I introduced a bit of warmth with Naples yellow and cadmium red light. Using these basic colors, I let the shapes flow back and forth, wet into wet, until I had a de-sign and sky I felt satisfied with.

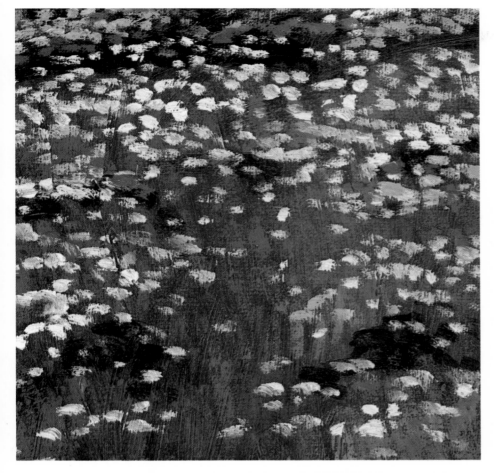

Bad

To the amateur painter, a pale flower is just "white," as painted here, with no feeling for color variations. Also, there was no consideration made for the foreground being in a cloud shadow, and therefore for its color being influenced by the cool sky above. For some reason students are overly affected by the fact there are hundreds of individual flowers, and fail to group them into a pleasing design. Also the flowers in the background are almost the same size as those in the foreground, defeating any feeling of distance.

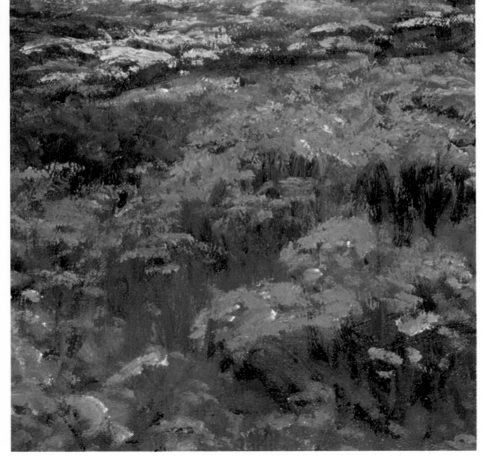

Good

The grass was laid in basically with permanent green light, with variations of earth colors painted into it while it was still wet. I used the deeper burnt umber to indicate stalks under the flowers, and raw sienna and burnt sienna to suggest some dried grasses among the lush greens.

In the flowers, I used mixtures of cerulean blue and alizarin crimson in the cool areas, and flesh tones where there was a feeling of warmth. The challenge here was to create a feeling of luminosity, without going as light as the middleground, where the sun is shining. Notice that we sense individual flowers only in the foreground.

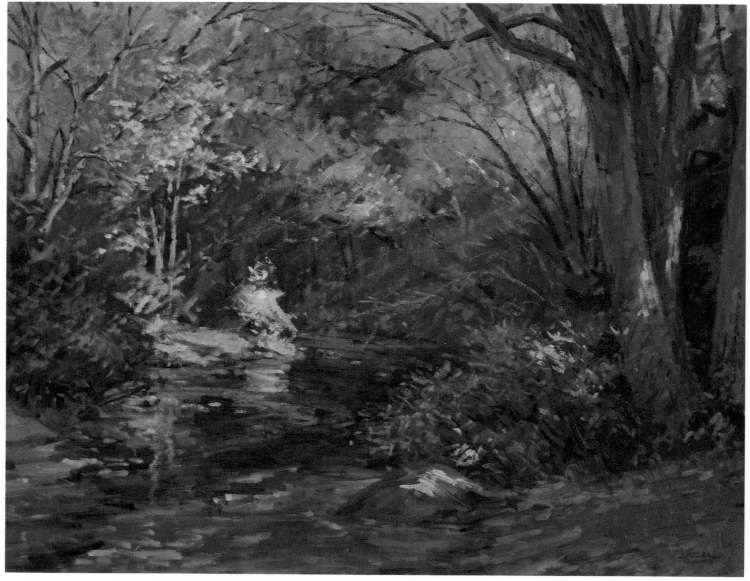

MT. MISERY STREAM, *oil on canvas, 24" x 30" (61 x 76 cm).*

I'm fortunate to have spots nearby like this quiet brook, and I delight in painting the beautiful abstract patterns they provide. I hope all of you someday can enjoy painting to the extent that I did when I painted this. I remember vividly that the weather was sunny, warm, and beautiful, my portable tape recorder was playing Viennese music, and I thought how lucky I was to be doing what I enjoyed so much. However, to be in such a happy state, you must have overcome the difficulties and frustrations of *how* to do it. You must be able to analyze the problems before you, and settle down to some enjoyable painting as you competently solve them.

I think there are more bad paintings made of the colors of autumn than of any other season. So many vivid colors are present, that the novice painter goes wild. But nature is always harmonious, even in its extremes. In these keys I shall take up in detail some of the points that I'm sure will help you paint the colors of autumn.

Overcoming Timidity in Using Bold Colors

Problem

In painting, there are times to whisper and times to shout—and you can see both in this painting on the left. Novices usually have trouble with both ends of the scale. Instead, they'll often go along on a monotonous middle ground, timid in the use of both color and value, thinking, "If it's wrong, it won't be too glaring a mistake." But they underestimate the amount of brilliance and gusto a passage needs to carry well from a distance. It takes many years of painting two or three feet from a canvas to learn to give it the bravado handling necessary. I hope to shorten that time for you with these examples and demonstrations.

Solution

Many times color can be used in its purest strength and strongest intensity right from the tube. I used it here in the section of the painting that I wanted people to notice first—the bush and tree in the center of interest—and played it up as much as I dared. Needless to say, the adjacent contrasting background colors and deeper values help, for in situations like this, much of the emphasis is attained by playing down the passages adjacent to the brilliant sections. When they aren't dark enough, you lessen any impact that the main passage might have. You'll find me referring time and again to this principle of contrast.

Introducing Rays of Sunlight to Enhance the Subject

Problem

I have yet to find students who have, on their own, ever attempted to introduce the dramatic effect of light rays into their paintings. Then, after I suggest it to them, when they paint the rays, they seem to make one of the following mistakes: They paint them much too light and too crudely; they don't make the rays fall in consistent angles from the source of light (the sun); or they taper the rays like a funnel because they don't realize that rays of light are parallel unless some object disrupts their path. Handled with sensitivity, rays of light can enhance the total effect of a painting and give an added feeling of atmosphere and light. But handled badly, adding light rays can be worse than not having them at all.

Solution

I often paint sparkling light on the subject. Since most amateur painting is rather dull and lifeless, this is one of the most important ways to get your work to look more professional. Sometimes I paint the light rays wet into wet, and other times, such as here, I add them after the background has dried for a soft drybrushed effect. Effects like this are very transient, and many times I simply imagine their presence. Either way, they generally have to be painted from memory. The secret is to keep them soft and unobtrusive, merely as an interesting addition to the overall story.

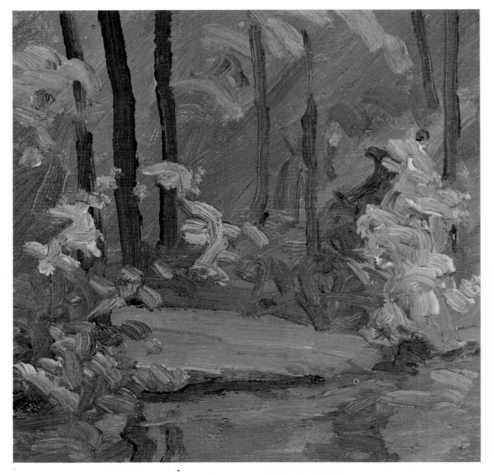

Bad
Here the colors that should be strong and brilliant are too dull. Even if, at some time in the morning, the light had shone on the area behind this foliage like this, I would not have painted it that way. Instead, I would have waited for the light pattern to shift to one that would provide a more advantageous background and give the lightest areas every bit of the benefit of a strong contrast.

Good
Here, the background area was laid in with French ultramarine blue with a touch of burnt umber and raw sienna. Into this I introduced a feeling of foliage in shadow with permanent green light. The bright foliage was basically cadmium yellow pale and white. In some places, I used a touch of permanent green light, and in others cadmium yellow deep. The presence of warm light on the earth creates a delightful passage among the yellow-greens. Notice how the tree trunks are suggested boldly with the combination of flesh and cerulean blue.

Bad
Effects like these rays of light have to be executed sensitively to be successful. Amateurs often lack the technical knowledge to know when and where to be either bold enough, or soft and delicate. In this sketch, the handling of the light rays is harsh, angles are inconsistent, and their value is much too light to convey the subtle effect we're after.

Good
In this particular instance, I painted the effect of light rays over the background after it was dry. Needless to say, they're most strategically placed against a shadow passage. I painted them with the cooler French ultramarine blue and white with a bit of flesh added to gray the mixture. Notice how I varied the sizes of the rays and the spacing between them to avoid the monotony of repetition.

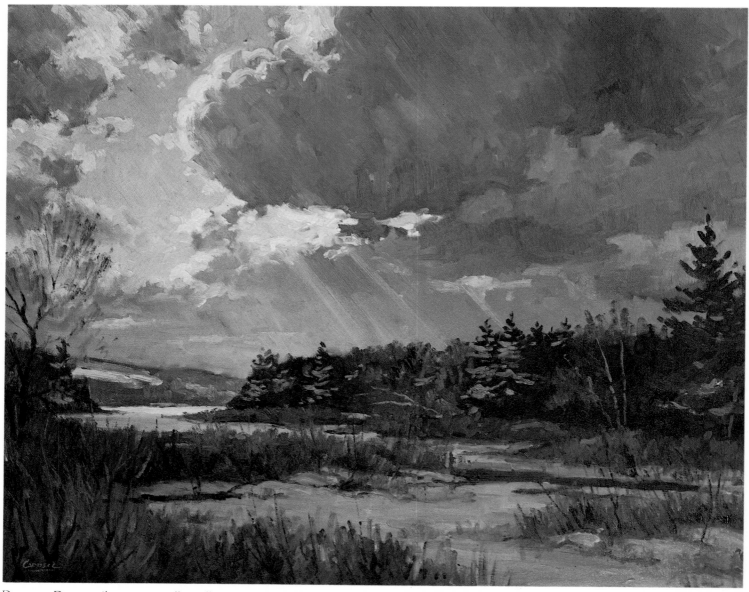

DECEMBER DRAMA, *oil on canvas, 24" x 30" (61 x 76 cm).*

As you progress further in painting and the technique of painting presents fewer problems, I hope you'll turn your thoughts more to *what* you paint. I never try to make an ordinary record of a place or scene but, rather, aim for an interesting interpretation such as the one you see here.

One of the main factors in outdoor painting, as you've undoubtedly learned, is that conditions don't stand still for you. Dramatic effects, such as the one you see here, are painted primarily from memory and

knowledge. The first prerequisite of making such a painting is to visualize the dramatic possibilities before you start. I decided that this painting was going to be primarily a sky painting. Since I never place two competing areas in the same painting, here you'll notice I devoted most of the canvas to the sky and threw the foreground into a cloud shadow to further subordinate it. At this time of the year, we normally think of the outdoors as being pretty bleak, but let me show you how to exploit color in a scene such as this.

Learning to See Colors in Clouds

Exploiting Color in Bare Branches

Problem

Everyone knows that skies are blue and clouds are white—but are they really? The primary problem students have when painting skies is a subconscious, preconceived idea that tells them that clouds are puffy, round, white balls of cotton. As I've said before, you must get used to *really looking* at the landscape. You can't take anything for granted.

Throughout this book, notice the variety of skies I've painted. Most of the time they're subordinate to the landscape, but in this painting they're obviously the dominant motif. Many people paint skies as though they were a flat curtain hanging behind the scene. You must learn to paint them so that they go back in distance, just as the landscape does.

Solution

The main idea in painting clouds is to introduce as much color as you dare, while staying within the limits of possibility for the time of day you're depicting. In general, though, I can safely say that most amateurs are not daring enough. Here, in the tonal climax of the sky, notice how I've dared to be bold with my colors and values. I've also used interesting grays, composed of the three primary colors. The whole idea is to realize the beautiful variations of colors possible, and not lose them by overmixing. In addition to the cloud forms, I've suggested rays coming from the sun in the upper left, outside the painting.

To paint skies successfully, you must make a study of them. Take your pastels outdoors and make color sketches of the various cloud formations. In this way, you'll build up an understanding of their shapes, colors, and designs, so that you'll have knowledge to fall back on when you try to capture a fleeting effect like this.

Problem

The basic problem here, and in all student painting, in fact, is that the amateur tends to put down what he thinks is the color of the object instead of learning to see the wonderful color that really exists. Our New England winter undoubtedly has far less color than the rest of the seasons, but if we were to see the leafless, dried-up branches in a cold winter wetland landscape as a non-painter would, we'd render them just an ordinary dark brownish gray. As an artist, you must not see in an ordinary way. You must learn to see things poetically, extracting all the possible color variations from the commonplace and ordinary item.

Solution

A very important part of the philosophy of painting involves the study of contrasts, or what I call "relativity." Of course, a bleak time of the year is depicted here, but because of the scarcity of strong colors, see how important the bit of color that we *do* have becomes. You have to learn to look for beautiful color, but it's there, and if you try, you can find wonderful color in the plain bare branches and weeds in a stream such as this one. There are purples here that range from red and earth yellow purples to those cool with blues. Notice the technique I used to render these grasses and weeds—seemingly casual brushstrokes, with only a bit of definition here and there, are enough to define them, since the mind of the viewer supplies so much of the detail. Also, note how much color I used on the distant hill. This warm color was justified because the sun was hitting some dried-up old oak leaves.

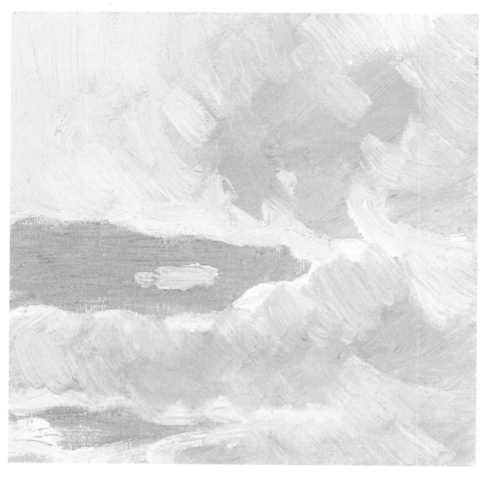

Bad
This sketch is poor because it shows a lack of understanding of cloud form and structure, and a lack of courage and daring. The cloud shadows are not sufficiently dark and their colors—just Payne's gray and white—too simple and ordinary. Also, the edges of the clouds are too stiff and uninteresting. All in all, it's a pretty poor conception and rendition.

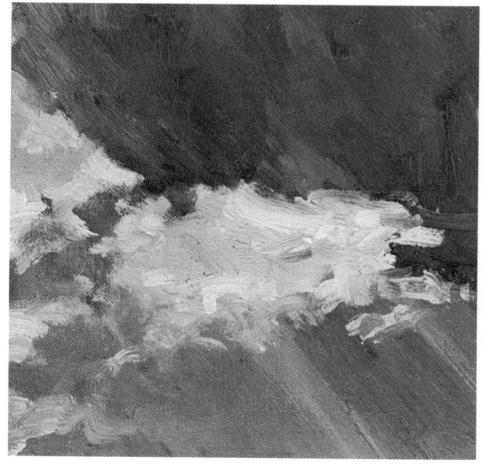

Good
Here there's diversity in the cloud shadow colors and values. The great contrast created by the light edges brings the viewer's attention up into the sky, where we want it. See how Key 3 on a tonal climax applies so obviously here. In the shadow areas I used cerulean blue, which I turned slightly purple with the addition of alizarin crimson and then modified to a gray with tints of cadmium red light and Naples yellow.

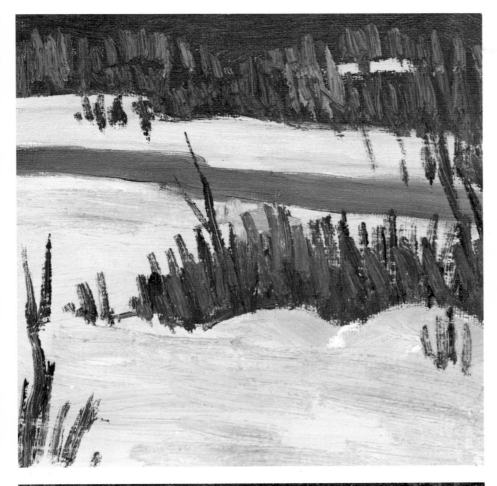

Bad
These weeds were rendered in variations of burnt umber, with no thought of other color possibilities. Painted with many individual brushstrokes in a clumsy effort to say "weeds," they take on the characteristics of a picket fence. Also, because water is thought of as being only blue, too much intense blue color has been used in the open channels. The snow passages also were painted just blue and white, with no effort made to find other variations.

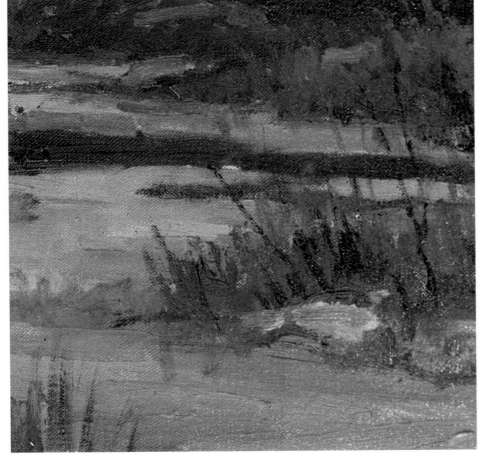

Good
The bare weeds were painted with alizarin crimson, French ultramarine blue, and variations of both raw sienna and yellow ochre, exploiting all their color possibilities. In this rendering, I've achieved greater feeling of texture and detail with far less actual delineation. The color of the snow is also much better here. The introduction of raw sienna gives a feeling of the ice sheets under the top snow.

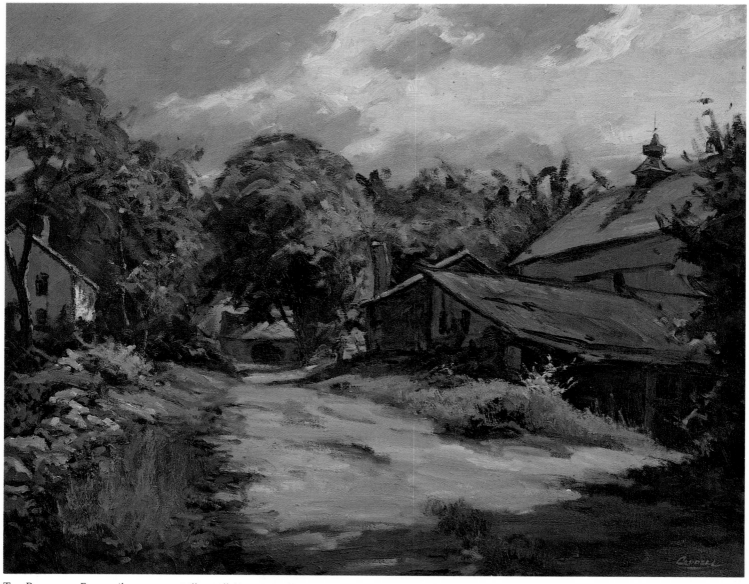

THE BROWNING FARM, *oil on canvas, 24″ x 30″ (61 x 76 cm).*

I'm fortunate to live in an area that still has a few old farms left. The geometric patterns created by the haphazard placement of the buildings never cease to fascinate me and provide material for my paintings. In these keys, I want to show you how a little artistic interpretation and feeling can enhance a subject. As I've always said, unless we paint more than just a literal record of a place, we're just displaying our ability to do by hand what a camera can do much more easily.

The colors in summer landscapes are rather general and are thus difficult to make interesting. Study the keys that follow to see how I handled the colors in this painting. For further information, you'll find a comparison of this subject with an actual photograph of the scene on pages 130–131. There I'll go into greater detail about my compositional changes.

Exploiting Colors in Commonplace Material

Problem

To be quite literal, these buildings on the left were a faded white, and the shed in the foreground of the group had a plain old tar-paper roof. But if you painted them that way, they'd be quite drab. Whether you're dealing with old buildings such as these, or a figure or portrait, one of the hardest things to get students to see is that darks that have light shining on them are no longer dark, and light passages without direct light on them are much darker than they realize.

While discussing problems related to this subject, I must add a word about drawing. Many people have difficulty drawing buildings. If this is your problem, too, I recommend that you get a book on perspective. Only after you conquer the problem of perspective will you be free for the more aesthetic challenges of color.

Solution

Here I was not bound by what I knew—that tar paper is black—but instead gave myself free rein to exploit and find colors in the plain old tar-paper roof. The white buildings became interesting cool grays because they're in shadow and thus are illuminated by the sky and by the reflected colors bouncing off the sunlit grass and nearby buildings. Notice the colors I found in the foreground grasses that come into full sunlight. See how I capitalized on the brilliant bush as it sparkles against the dark interior of the shed. The red roof of the main barn was a fortunate color. Since red is the complement of green, I always take advantage of every opportunity to introduce it subtly into a green summer painting—but I did not let it become too plain. I painted it so you feel the presence of the sun basking down on it. Even though these buildings are rigid, solid forms, note the free handling in my brushstrokes.

Improving Color Through Artistic License

Problem

My basic policy in painting outdoors is to use everything there that's good—and change and improve what isn't. The first change I made was on the road. Tar roads are nice to drive on, but I find them very unsuitable in the type of rural subject that I enjoy painting. Not only is their color uninteresting, but there's a rigid quality to the side edges of the road that is a consequence of man's pouring asphalt over grass and earth. The second change I made was in the buildings. I never saw anything like the building that actually was at the end of the road—it was rather like an ecclesiastical garage, and not at all in keeping with the rural feeling I wanted in the painting. (I'll show you what was really there in the "bad" demonstration painting on the following page.) Finally, the grass area at the lower left-hand side in front of the stone wall was rather uninteresting. I'll tell you how I borrowed material for this section in the "solution" below.

Solution

By converting the tar road to a dirt one, I got much better color. It gave me a way to introduce warmths to balance the dominance of greens found in summer paintings. The edges of the road were less rigid now, too, since grass and weeds flow into the dirt sections. Also, I could introduce bits of green grass in the less-used center section of the road, as I usually do.

Having painted this type of subject for years, it was easy for me to convert the building at the end of the road to a typical old barn. Note the effective use of the color and directional thrust of the sunlight hitting its roof.

When faced with a dull, uninteresting area, such as the grass by the side of the road in the lower left-hand corner, I simply keep my eyes open for better suggestions. I noticed the wild daylilies while driving to this location one day, and transferred them from another roadside to the one in my painting for a bit more color.

Bad

This is a classic example of what happens when you're too literal and unimaginative. Using Payne's gray and white to paint both the tar-paper roof and the sides of the buildings is just plain bad. The sketch also shows too much concern with the wrong things, such as indicating clapboards, and not enough aesthetic feeling for introducing beautiful color. The red roses, for example, show the use of only obvious color. Also, because the roses looked good across the street near the house, they were painted next to the barn, too. But many amateurs don't know when to stop, and so keep repeating a solution again and again. The touch of red in one area is interesting; used again, it becomes monotonous.

Good

By observing the loose, spontaneous treatment in this detail, you can see my delight in exploiting color. The intermingling of alizarin crimson and cerulean blue painted wet into wet with a Naples yellow gives fascinating color variations in the tar paper. You get a definite feeling of sunshine sparkling in the trees and roofs in the top of this section. Notice the way the grass and light-colored bush shimmer against the dark interior of the barn. Also, study the variations in greens I created with just permanent green light, cadmium yellow pale and deep, and white.

Bad

In this rendition, everything is painted in a flat way, without any imagination. The white building is simply painted white, and the tar road blue-black. Because the colors and values are incorrect and unvaried, there's little, if any, sense of sunshine playing upon the scene. To correct this, you must develop a way of thinking that will make you see the subject of your painting more artistically than it really is. You must also learn to be bold in your use of color and contrast, though this seems to be difficult for amateurs to achieve.

Good

Note the beautiful warm colors that are possible by simply changing the tar road to a dirt one. This one was painted with white, yellow ochre, and a touch of cadmium red light—with a few cool grays to indicate stones in the road. Note the soft edges I could now use on its sides (a dirt road merges with the edges of the road—a tar road doesn't) and the introduction of green grass in the less-used center. The light on the shed roof is a mixture of flesh painted over cerulean blue, and the sunlit greens are a combination of permanent green light, cadmium yellow pale, and white. The barn interior, being this far back in the painting, is never painted as dark as the one in the foreground.

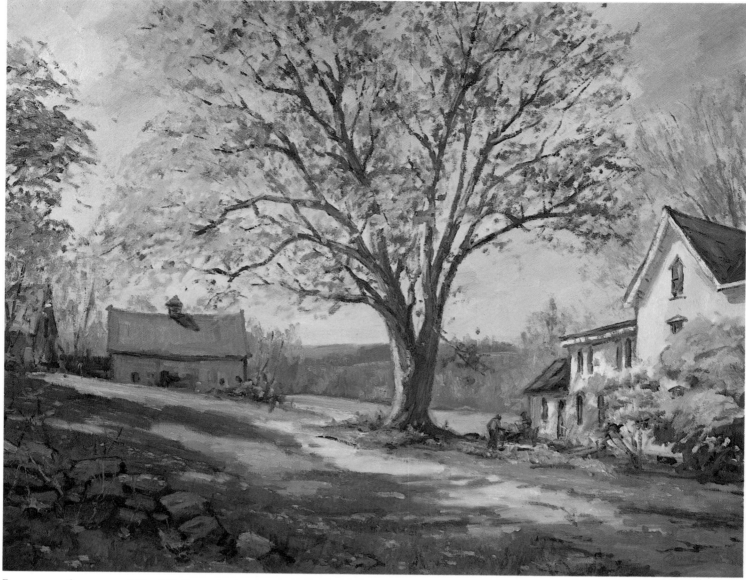

PRIMAVERA, *oil on canvas, 24" x 30" (61 x 76 cm).*

I've mentioned elsewhere the concept of an artist having potential paintings in mind, just waiting for the time available to make them. This was one of those paintings, for, although I'd painted the landscape all around this farm, I'd never actually painted this particular scene.

This is primarily a study of a huge maple tree. The fact that it towers over the three-storied Victorian home gives you a sense of its proportionate size. If you refer later to pages 132–133, you'll see the compositional changes that took place in the making of this painting. Actually it wasn't so much what I changed but, as you'll see, what I left out.

Spring colors are different from any other season. There's a freshness to them, like youth itself. I hope my thoughts in these two keys will help you with your own spring paintings.

Painting the Colors That Say "Spring"

Problem

Having committed myself to making a spring painting of this scene, my first consideration was how to best interpret it. The main subject is the huge maple tree. I note that its lacy foliage is playing against a large sky area. These are the type of facts that should be analyzed *before* the painting gets underway. My objective, in this case, would be to paint a sky that not only says "spring," but also is a good background for the colors and values of the tree to register against. You also have to carefully study the effects of the atmosphere on the color of the trees at this time of year. The viewer may not know all the correct answers to these problems, but he'll sense that it looks right—and it will, if you take the time to study nature and do a lot of thinking and analyzing before you begin to paint.

Solution

You must first decide what the sky is to accomplish here, then paint one that best serves your purpose, yet one that still looks like a typical sky to the viewer. In this case, I decided the sky had to be darker than the light green buds on the tree—yet not too dark. Whereas the primary color in the tree was a yellow green, I wanted the sky to be a purplish gray, because it would enhance the tree color better than just plain blue. Spring is noted for its off and on showers, so from memory and theory, I painted a sky that felt as though the sun was breaking through after a light shower, and that, technically, gave me the background color and value I wanted. In the colors of the trees and hills under the influence of aerial perspective, notice the purplish base—a hangover from the bare branches of winter. As the buds come out on the trees, beautiful warm colors appear, which makes you think of a softer version of the colors of autumn.

Seeing Colors and Designing Shapes in Stone Walls

Problem

One of the problems in painting stone walls is in getting the right colors. If you were to ask a novice painter what color rocks or stones were, he'd undoubtedly say "gray." Amateurs not only think of rocks as being the same color, but they conceive of their shapes as being alike, too—to the boredom of the viewer. Another problem here involves composition. I sensed that something was needed in the lower corner to balance the house on the right. But it couldn't be too important or interesting, or the viewer would never be able to go beyond it to the main subject—the tree and barn in the middle distance.

Solution

To paint a stone wall, you must avoid seeing and thinking of it in an ordinary way. You must really look at it to see the many colors present in the stones. If you study rocks outdoors, you'll find the presence of lichen and moss, which will also make a diversity of color possible.

To correct the composition, I had to design something in the corner to balance the house, yet add nothing that would be too distracting. I decided to keep the wall as well as most of the foreground in shadow. I imagined that the shadow was cast by large, unseen trees that were outside the painting on the left. By lowering the value and intensity of the foreground color in this way, I allowed the viewer to more readily get into the middle distance, where the subject of the painting was situated. In addition, I designed the wall to conform to the flowing shape of the hill, and I made sure that various sizes, as well as many colors, were present in the rocks. If you refer to the photograph of the site on page 132, you'll see that there was actually another type of stone in the foreground.

Bad

Here, no attempt was made to hold the sky down in value in order to allow the pale green leaves to register against it as a light rather than a dark. In fact, this entire study demonstrates the lack of sunshine often found in amateur work. There's no feeling of atmosphere. The trees on the hill are lacking in the desirable purplish color that you see below. The green field lacks the feeling of sunlight—since the left-hand side of the field should be lighter in color and value than the side of the barn. The branch shows a lack of sensitivity in handling at the top, especially in the polkadot rendering of the leaves, which again is so typical of an inexperienced painter.

Good

I initially painted the sky with a light tint of cerulean blue. Then alizarin crimson and Naples yellow were introduced into this color in order to obtain a soft gray, one slightly purple and darker than the light green leaves of the tree. The leaves were painted with cadmium yellow pale, white, and a touch of permanent green light. The basic tree color in the distance is French ultramarine blue, alizarin crimson, and white, and I painted warms and light green into it while it was still wet. The distant hill is a cold blue—remember, I use French ultramarine blue, not cerulean. Note the harmonious colors found in the barn and the general freedom of execution throughout.

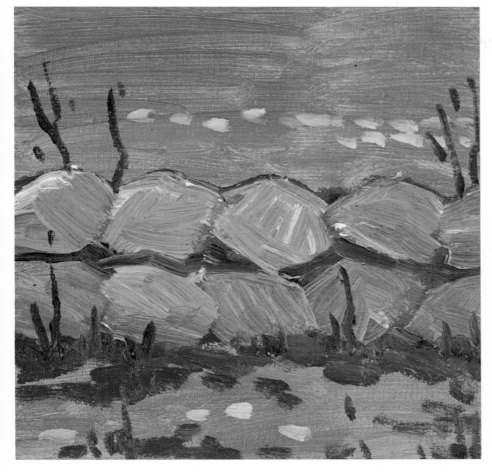

Bad
This demonstrates, both in color and design, the thinking of so many amateurs. They not only select an ordinary color and repeat it everywhere on the rocks, but their subconscious orderliness tends to make them paint the rocks the same shape, as well. This is the same thinking that makes them render foliage as polkadots—we see it here also in the dandelion pattern. The brush, weeds, and dead leaves around the wall are handled in a most unsympathetic manner, and there's no feeling of sunlight anywhere.

Good
Here you can study a closeup of my treatment of the wall and the subtle warm and cool colors in it. It's handled in a casual way and rendered in deeper shadow tones so it will be part of the composition, yet not detract from the main items above it. Notice the suggestion of vines that grow over a wall of this type and the hint of different shapes and colors of weeds in front of it. The dandelions indicated on the grass not only add color variations, but help the overall effect of spring as well.

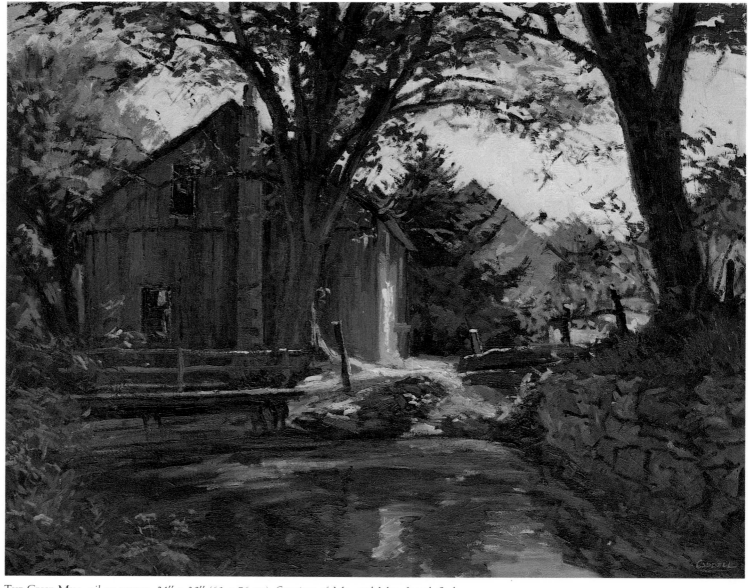

THE GRIST MILL, *oil on canvas, 24" x 30" (61 x 76 cm), Courtesy of Mr. and Mrs. Joseph Scola.*

This is a delightful spot, and the mill is a wonderful subject for a painting. It happens to be one of the few authentic old grist mills still in operation, and, in addition, gave me a fortunate setup I don't often find—a weathered old red building for the center of interest of a green summer painting. Although this was ideal material for the basis of a painting—the building itself, a beautiful old elm tree near it, the lovely reflections in the stream, and the footbridge over it—many technical problems had to be solved before I could make a successful painting out of such promising material. This is what I'll take up with you now in these keys.

Exploiting Color in Reflected Lights

Problem

I'm constantly reminding new students that they won't make great outdoor paintings unless they're well trained in the craftsmanship that's developed in the studio. The absence of this basic knowledge is one of the main problems I find with so many students. One of the many subjects that should be studied long before you go out into the field is reflected light. When an object is hit by direct light, reflected light is the colored light that bounces off and is deflected into a nearby object. The stronger the illumination, the shinier the object's surface, and the brighter the color of the object hit by the light, the more color and light are reflected into nearby objects. If you learn and practice the principles of reflected light in the studio, you'll see it more easily when you paint outdoors, and will be better able to take advantage of the lovely color variations it provides.

Since many students don't paint on location often enough, when they do, they lack the experience to see and utilize some of the delightful passages that are there waiting for them to grasp. Great paintings, like great performances, are not the result of ideal conditions or subject matter, but rather of having the necessary training and background to know how to make the most of the subject and conditions at hand.

Solution

When painting reflected lights, remember that they can never be as bright as the lights, but must be more luminous than the general shadow value, and show an influence of the color of the area that they're reflected off. This is as true of the reflected color from a blouse shining into the shadow side of the face as it is in the example shown here, where the sunlight is reflected off the warm earth into the shadow side of the mill.

Painting Luminous Colors in the Sky When Facing the Sun

Problem

Backlight is not easy to paint, but when it can be used in a painting, and is done well, it gives us a great feeling of radiance and luminosity. The main problem in painting skies (backlit ones included), as you'll find me saying again and again, is that of overcoming the influence of preconceived ideas. Skies are usually painted too blue with little, if any, feeling for the variations that can be made by adding other colors. In addition to making skies the wrong color, it's hard for amateurs to paint a backlit sky like this one brilliant enough. However, with experience and practice, you'll gradually make the correct decisions and use enough color to make your painting artistic and interesting, but not so much that it becomes overpowering. Of all your difficulties, color is the toughest one to surmount.

Solution

By going outdoors and studying nature carefully, you'll learn that skies are usually lighter when looking toward the sun than looking away from it. Also, you'll see that a sky should "arch" in value. That is, it should be painted lighter near the horizon, and should gradually deepen in color and value as it goes higher.

Another way to achieve a luminous effect is through contrast. By strategically placing darks against the sky, such as the large tree trunk in this instance, and by painting the shadow side of the white house in the distance much darker than the sky, you can create the effect of a very bright, luminous sky. One of the secrets in exploring beautiful color variations is to keep your values consistent, whether it be in the darks of a tree trunk, the shadow side of a house, or the bright sky.

Bad
Here's another example of stating individual items rather than focusing on the play of light upon them. There's too much concern in showing that the building has a white door and window, and no attempt to get a feeling of light falling on the scene as a whole. The colors are too ordinary and matter-of-fact, and there isn't enough bold contrast. There's also no feeling of delight in handling pigments here.

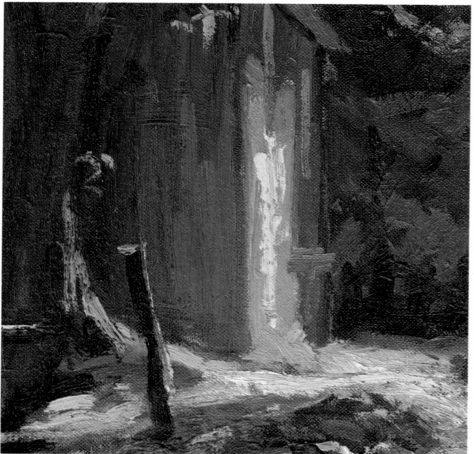

Good
Here we can almost feel the sunshine beaming down on the sandy area and being reflected up into the shadow side of the building, giving us such a lovely warm color. Notice how this area of color attracts more attention than the illuminated section of the mill. Shadows are usually cool, but here the color is warm. The critical factor is getting it just the right value. Notice the delightful splash of white that sufficiently says "door" and "detail" on the front of the building.

Bad

The sky here is painted plain blue, with no other diversification of colors, a habit some amateurs just can't seem to break. Also, thinking of the house as being plain white prevents a student from observing that it's really darker than the sky, and should be painted as such. The foliage greens are also monotonous in design and color, and the tree trunk has been painted an ordinary brown.

Good

Here's a marvelous example of the range of values you can achieve with the three primary colors. The tree trunk was painted with French ultramarine blue, alizarin crimson, and raw sienna, which gives us a strong dark. The sky was painted primarily with Naples yellow, and while it was wet, cerulean blue, alizarin crimson, and cadmium red light were painted into it. (Of course, white was added to all these light colors.) The white house, being in shadow and thus dark, is silhouetted against the sky, adding to the sky's luminosity.

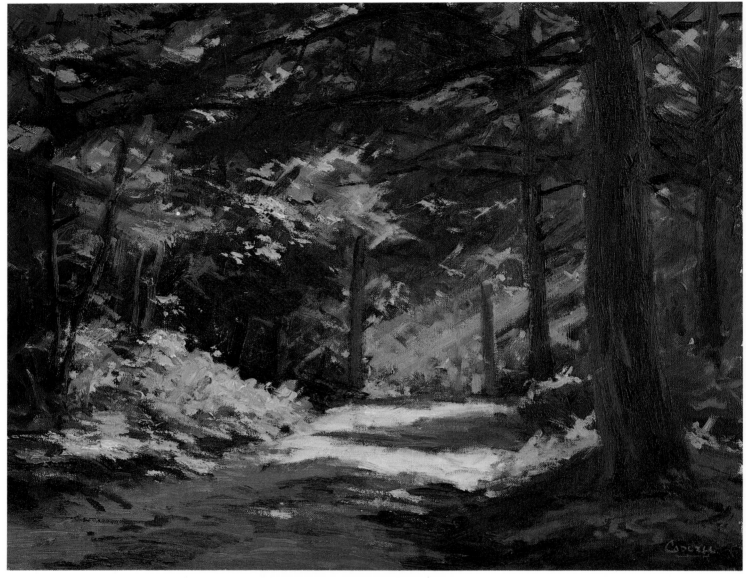

THE FOREST ROAD, *oil on canvas, 16″ x 20″ (41 x 51 cm), Courtesy of Mrs. Foster Caddell.*

The longer I paint, the more subject matter I find in the ordinary. But to take the ordinary and paint it in an extraordinary way—to make a work of art out of it—takes knowledge and skill. As one of my great teachers used to constantly remind me, "When the subject matter dominates the execution, the painting has failed."

This is a painting of a road in our nearby state forest. Among other things, the scene gave me an opportunity to paint a real dirt road first hand. Having had

such experience, I'm now able to improvise the dirt roads that you see me introduce into all my other rural paintings.

As I've stated earlier, a predominately green painting is not easy to paint. Also, the subject matter isn't at all spectacular. To come up with a good painting, you must approach it as almost a pure abstract design of pattern and color. In these keys I'll discuss with you in detail some of the important thinking that went on as I made this painting.

Capturing Sparkling Sunshine by Using Strong Contrasts

Problem

People are amateurs because a lack of knowledge and experience makes them unable to make correct decisions. If you're unable to judge the correct amount of contrast, you'll either paint too much or too little, although, frankly, I can't remember a student *overstating* the amount of contrast necessary. Students always seem to understate it because, afraid of making a mistake, they don't want it to be a glaring one. As a consequence, they're hesitant about being bold in either contrast or color. On the other hand, students are constantly complaining that when they take their paintings home, they lack a feeling of sunshine. I can absolutely guarantee that the prime reason their paintings lack that feeling of sparkling sunshine is because most students don't use enough contrast. It seems to take years before you learn to give a painting the contrast necessary for it to carry well from a distance. I hope the knowledge that I've gained from seeing hundreds of students will make you more aware of your own shortcomings and speed up your progress.

Solution

To take a flat piece of canvas and the material we use, which is a high-grade housepaint, and with them create space, air, and sunshine requires every bit of knowledge and information you can assimilate. It really takes a terrific wallop of pigments to create a sunny effect at times, and it seems to take the average amateur years of painting to learn to be bold enough. Sadly, I must report, some painters never achieve it. I'm sure you can recall seeing many paintings lacking a good sunny effect.

Sunshine is created by strategically playing lights against darks. I can't give you any actual rules for this other than being bolder and using more color and contrast in the manner that you see in the paintings reproduced in this book, but study my work and try to understand how and where I've applied this principle.

Finding Color in Just Plain Dirt

Problem

So much of painting, like life, is a state of mind. I had a friend who went to Venice expecting to find a smelly city without a sewer, and that preconceived idea, I'm sure, dominated his whole impression of this glorious city. I went expecting to find beauty, and I did not smell the water at all but, rather, saw only beautiful colors and reflections in the canals. Most amateurs look at a road like this and to them it is just plain, dirty, yellow earth—and they paint it as such. A piece of art should be artistic, and we, as artists, must learn to see beyond the ordinary and use color just as the poet uses words. The problem is to train yourself to see a fascinating light pattern on the road, and render each section in beautiful colors.

Solution

When I'm teaching my classes to paint a road like this, the analogy I make for color is that the solution is rather like the result in cooking when the taste is both "sweet and sour." By that I mean, the pleasant blending of two complements. While a road like this is basically warm in the sunlit sections, in the shadows you must paint the cooling influence of the sky above, since it illuminates the basic earth color. I usually paint a basic cool underpainting first of blues and purples. Then, while it's still wet, I paint into it the local colors of the yellowish earth until I feel that it's just the right combination of each. One caution—keep the general values of the road similar. The darker values there indicate the coarser gravel, stones, and debris that often clutter a dirt road. Besides giving variety, the dark values also make the general area appear more luminous by comparison or relativity. See how I used the tooth of the canvas and the dried underpainting to get fluid, soft edges to my pattern.

Bad
Because the areas that the sun is shining on, the lighter greens, aren't light enough, we don't have a feeling of sparkling sunshine. This proves that even when the darks are almost the right value, we need the proper value in the lights, too. The handling of the greens is also monotonous, showing no variation of sizes, shapes, and textures. For some reason, students tend to paint tree trunks brown and often space them too evenly and repetitiously.

Good
Greens are a difficult color to master. To get atmosphere in the dark green passages, you must introduce cool blue (French ultramarine blue) into your darkened viridian green. For a bit of relief, I have flicked a bit of burnt sienna into the dark greens. This color comes from the dead, bare branches of the pines. The highlight greens vary according to the particular tree. Some are yellow green, with cadmium yellow pale predominating; others are more neutral green, with high-keyed flesh and white added.

Bad
This is how many amateurs would paint this subject. No attempt has been made to find interesting colors. The shadow area has been painted with just a darker version of the earth yellow road. The edges of the pattern are too hard. The sunlight on the road ends at the shoulder—it doesn't flow up over it. This is an absolute sin, as far as I'm concerned, as the termination of light patterns should never coincide with objects.

Good
Here the sunlit section sparkles and the pattern flows up over the pine needles on the shoulder of the road. In the shadow section, you can observe more closely the influence of cool purples and the small passage of green which suggests the grass that often grows in the center, less used, section of the road. The shadow section is first underpainted with French ultramarine blue and alizarin crimson—then, while it's still wet, I paint the earth color into it with raw sienna and yellow ochre. It's most desirable to exploit every possibility for using colors like these in a painting so dominated by greens.

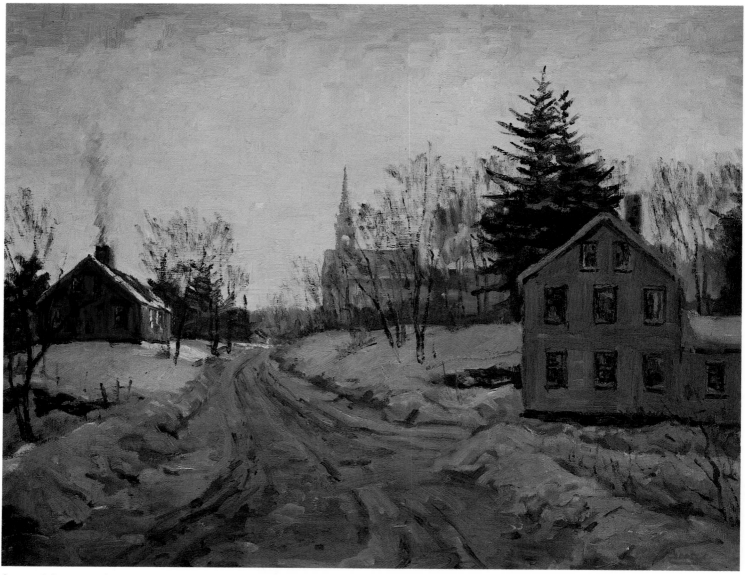

Sᴜɴᴅᴀʏ Mᴏʀɴɪɴɢ, *oil on canvas, 24″ x 30″ (61 x 76 cm).*

I've long felt that this scene approaching our little town had great possibilities as a winter scene, for the bare trees allowed us to see the church on the knoll. But it wasn't until I became engrossed in this book and wanted to give you a full spectrum of our colorful seasons, that I managed to find time to paint it. In my paintings, I try to capture impressions that are a bit out of the ordinary, such as the fleeting effects of light on a subject. I decided to do this a bit differently and catch the early morning light just as it broke over the landscape. To paint snow successfully, there are many technical points to consider. I shall discuss them with you in the following keys.

Learning to See That White Isn't Always White

Problem

The first problem here is to paint the white church and snow areas dark enough to capture the great radiance in the sky from the rising sun, yet still light enough to be accepted as white by the viewer. Another problem is to get as much color as possible into the sky, yet not overdo it so that it loses its subtle quality and looks like a sunset. In addition to these technical problems, nature herself creates some: Effects like this are so transient that they have to be painted from a fleeting image; also, it was darned cold out there before sunrise. These are about all the problems an artist should have to cope with in one painting!

Solution

The answer to problems like this, as in most paintings, is to have the technical ability to say anything with paint, and the intestinal fortitude to go out to nature on a morning like this so you can actually observe what is going on. To capture the still coldness of this winter morning, you must analyze carefully just what you see—what is happening in value and color that gives you this effect—and put it down accurately on your canvas. The crucial judgments here are the value relationships between the sky, the church and snow, and the bare branches and brush. Concentrate on these big problem areas and not on the superficial detail that always seems to fascinate amateurs. This principle is true in all painting, but here especially you're forced to paint broadly by having to wear gloves. I go out and paint at a spot like this for several mornings so I can recheck my thinking against the actual conditions. As a matter of fact, that's how I saw the wonderful color in the rising smoke from the wood fires.

Finding Wonderful Colors in White Snow

Problem

I'm sure by this time you realize that I'm repeatedly talking about major principles. At times they may seem repetitious, but I want to make you aware of their importance and how they apply under various conditions. The problem in painting snow is that you may be dominated by your preconceptions of its color—especially if you don't actually go outside and see what's really going on. If you were to ask the average person to describe the color of snow, he'd probably say it's "white." But a painter can't be dominated by such thinking. You must learn to see beautiful colors in everything.

Solution

If you try to see the world as though you were just placed on this earth, with no preconceptions about what things are *supposed* to look like, your vision would be much more accurate. Also, try to see things poetically. It may be difficult at first, but work at it; I can guarantee that, as you begin to master it, your work will look more and more professional.

To paint snow, you must realize that, because all colors are present in the color "white," snow contains all colors. So the basic principle to remember when painting snow is to see and paint as much color into it as possible, and still have it accepted by the viewer as snow. When not in direct sunlight, snow is illuminated primarily from the sky above, so the colors of the sky should also be evident in snow. Although shadows on snow are basically cool, see how many warm colors I painted into my basic blue underpainting.

Bad
The basic error here is not only in color, but in value relationships, too. The sky isn't light enough, and the orange painted into the blue to make it warm has made it dark and dirty. (As you probably know by now complements neutralize or gray each other.) The church is not dark enough, for it should register against the sky as a silhouette and not have to rely on an outline to make it stand out. The foreground snow should be darker, and more beautiful color should have been realized in the brush and trees.

Good
The critical factors here are the value relationships between the three main elements—the sky, the church and snow, and the trees and brush. The sky is a radiant warm color, painted with Naples yellow, cadmium yellow deep, alizarin crimson, and a bit of cerulean blue. The church and snow are basically cerulean blue and alizarin crimson. The trees and brush are executed freely with French ultramarine blue, alizarin crimson, and raw sienna. Notice, if the value and color is right, how little detail is actually needed.

Bad
There are absolutely no variations of color in the blue here. Where snow mounds have been indicated on the side of the road, they're repetitious in shape and size—a common error among amateurs. The same error exists in the stone wall, where all the stones have been painted the same size, shape, and color. There's no awareness that, in this section of the painting, the source of illumination is a soft top light from the sky.

Good
The basic underpainting here was made with cerulean blue—a warm blue—and alizarin crimson—the coolest red—which gives us a beautiful, muted, luminous blue. In some passages, I introduced warm tones with Naples yellow, yellow ochre, and cadmium red light superimposed into the basic underpainting when it was wet. Notice the brushstrokes—even though they're free and spontaneous, they're always indicating form.

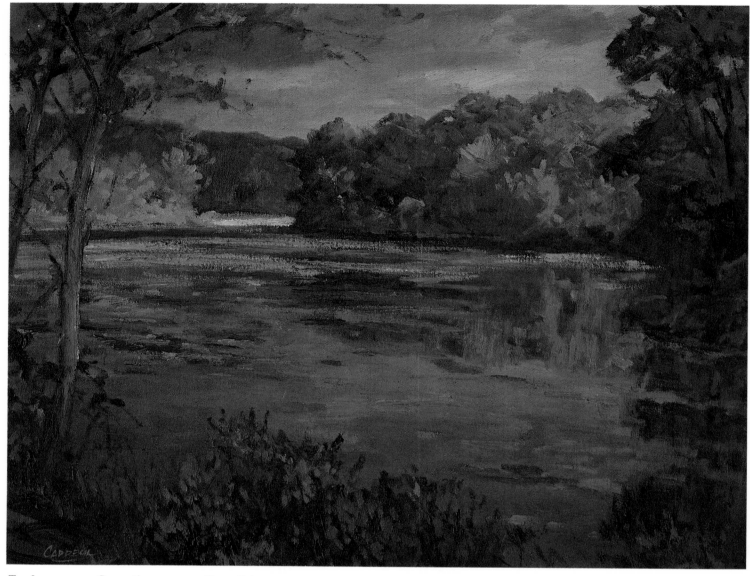

THE LIGHT IN THE COVE, *oil on canvas, 16″ x 20″ (41 x 51 cm).*

I saw this effect late one afternoon when returning from an errand to a nearby town. We're fortunate in having many ponds and wetlands in our area and, as you may have noticed, I enjoy painting them. Unfortunately, I wasn't prepared to paint on that particular day, as I had neither the time nor the materials. Since I never rely on colored slides, as some painters do, I didn't photograph the effect, either. When I returned to paint it a few days later, the original color effect was not the same—but I already had the version that I wanted firmly fixed in my mind. So, the final painting is a combination of the effect I saw the first time, coupled with my first-hand observation of the subject at a later date.

Those of you who own my previous book, *Keys to Successful Landscape Painting,* will find still another version of this same place on page 139. I did that one with a morning light, after a spring shower. A great deal of that painting was also done from memory. Some of the greatest effects are so transitory.

Painting Fleeting Color Effects from Memory and Theory

Problem

As I explained earlier, I wanted to paint the scene as I'd seen it a few days before, but when I returned with paints and canvas, the beautiful color effects were gone. So in order to transform this ordinary scene into the dramatic one I remembered, the problem was to paint the earlier lighting from memory and theory, using the present scene for reference. I paint almost all of my landscapes directly from nature. Many painters who don't, feel that this encourages a slavish, literal reproduction of the scene. But I think paintings like this one prove that this doesn't have to happen unless you let it.

When you first start painting on location, you may have a problem coping with the rather minor changes that occur in the lighting during the course of a morning or afternoon, especially if you're used to the consistent lighting conditions of a studio. To make major changes from what you see may seem impossible at first, but you can do it once you've acquired enough knowledge. Remember, you must be able to visualize the finished effect in your mind's eye before you start—in other words, you must have a definite goal in mind. Then, besides being a good technician with paint, you must have the feeling of a poet, and the sense of drama akin to that of a playwright. The problem is complex—I never told anyone it was easy—but it's amazing what you can achieve with diligence and perseverance. You'll probably start by painting a different sky effect from the one that's there, feeling that it will improve your painting. Gradually you'll notice that it was more interesting when the distant hill was in cloud shadow, and paint it that way long after it has passed. In time, you'll be able to make greater changes from what you actually see, and paint more and more from memory and theory, as you see demonstrated on the opposite page.

Solution

As I'm constantly reminding my students, unless your painting looks better than a photograph, you're better off using a camera, which is why I have little sympathy for the current trend of photo realism. The main point is that, to exist as a great work of art, a painting must be more than just a literal record of a place. I sensed this years ago, and gradually, as I began to be aware of and admire dramatic solutions in the work of more experienced artists, I developed the courage to try for more unusual effects myself. I hope my work will do the same for you.

Now, on the subject of changes, you must remember one thing. If you change something in your painting, you must do it in a way that *could* have happened. First, this requires a thorough knowledge of nature and its many moods and variations, which is only acquired by going out and painting directly from nature year after year. Then, you must be able to theorize just what happens, for instance, when you change the position of the source of light. You must also be able to visualize a remembered effect that's better than what's actually there. And finally, you need the technical ability to manipulate the paint so well that you can put down all that you visualize and feel.

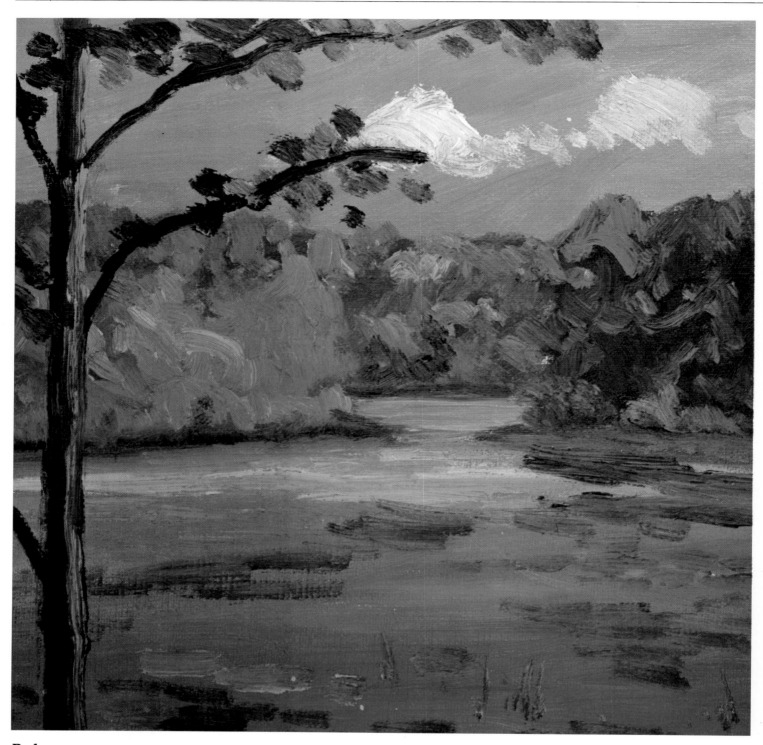

Bad

The average amateur has trouble painting a different version of a scene from the one before him. What you see in this sketch is a combination of the more ordinary effect that was there when I returned to the scene plus the typical mistakes amateurs make. The main problem here is that everything has the same emphasis. The drama of the scene is lost because the work lacks a definite value pattern, and because color has not been exploited. The sky is an ordinary blue, and contains spotty white clouds that always attract attention, drawing it away from other areas. The foliage is rather monotonous because no effort has been made to play lights and color against darks. The water is too plain a blue, and bears no relation to the sky above it. Also, not enough color has been exploited in the masses of pond lilies in the distance. The color of the pond lilies in the foreground is ordinary, and, because the colors are not graded properly, the perspective is wrong. With no feeling of atmosphere, they don't recede, and they fail to lie flat on the surface of the water. The foliage on the nearby tree is also poorly handled, being repetitious in both shape and design.

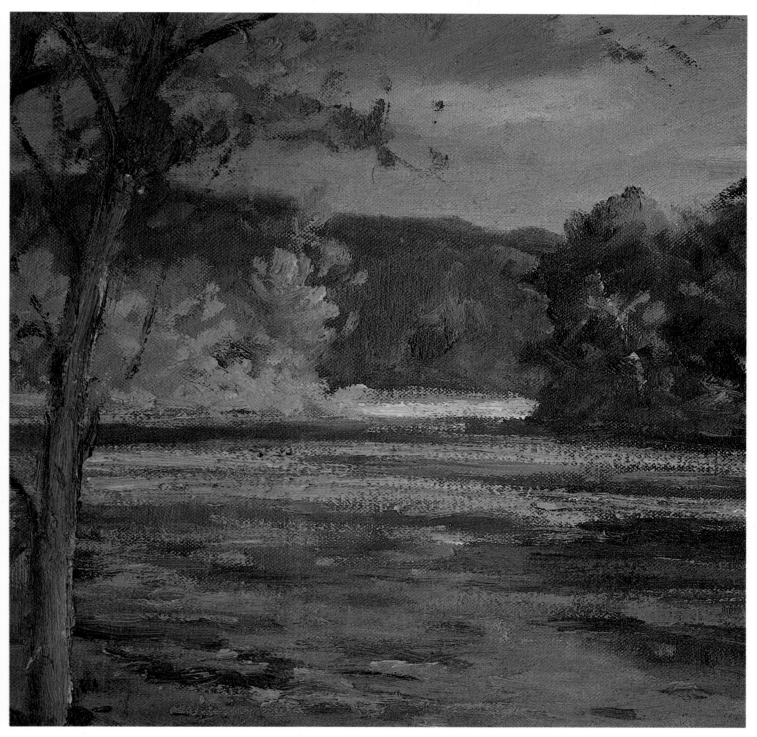

Good

I painted this dramatic cloud formation from memory using French ultramarine blue, alizarin crimson, and flesh. I kept their values down and repeated the purple variations in the blue water where the sky was reflected. I remembered that, at one point, the distant hill was covered with a cloud shadow. I decided to paint it that way now because it gave me a dark background to register against the lights of the center of interest. The red tree is brighter and taller here than it actually was, and is painted primarily cadmium red light. The light foliage is a combination of cadmium

yellow deep and cadmium yellow pale, with a touch of permanent green light superimposed over it. I achieved a feeling of light on the distant water by imagining that the wind was rippling it, and then by painting the glints of light reflected in these ripples. Notice the colors I was able to find in the pond lily masses. The flesh color predominates. Study the variety of ways that I applied paint in this detail. Technique is important, but it's one of the last things you learn in painting.

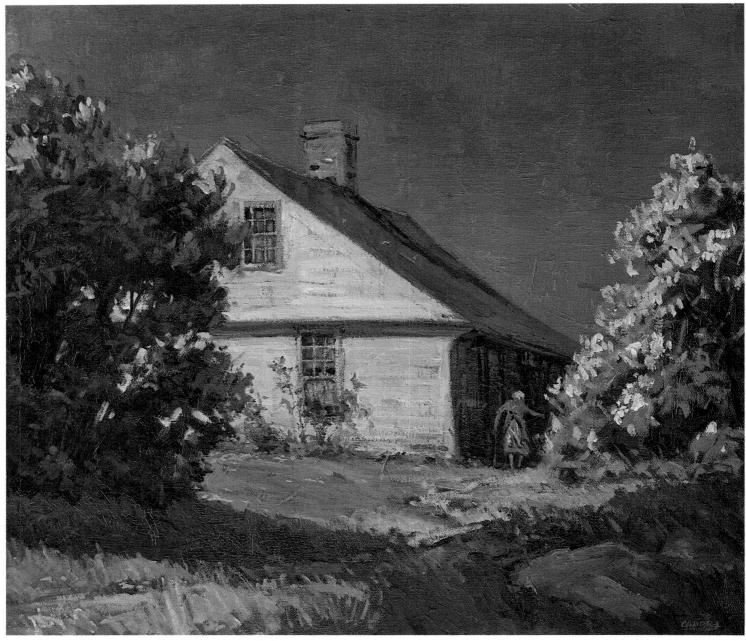

EMMA'S PLACE, *oil on canvas, 23½″ x 26½″ (60 x 66 cm).*

The village that I live in was once a part of the vital New England textile empire. The mills have gone, but we still have many of the small old cottages that give us historical charm and good painting material. I made this painting some years ago and, for sentimental reasons, have kept it as part of my own collection. The fascinating colors found in these weathered old buildings can only be duplicated by paint on canvas. As interesting as the house was, so was the dear old gal who

lived there. In her late eighties, living alone, and cooking on an old wood stove, Emma exemplified the rugged self-reliant character that built this country. Today this structure has changed because the new owners have painted it a barn red. I also show it from the opposite direction in *Sunday Morning* (page 72), where you can see it on the left. As interesting as this subject inherently was, I still gave it a dramatic interpretation—and that's what we'll discuss in these keys.

Finding Fascinating Color in Old Buildings

Problem

There's more than one way to solve many problems, but I hope that by seeing how I handle some typical ones, you'll be able to make better decisions in your own work. The problem here was to find interesting colors in these old buildings. As I've said before, it's easy to paint fascinating colors if you find the right subject matter, possess the sensitivity to see subtle color variations, and have the ability and technical training to reconstruct them with paint. But seeing color is also psychological and is a matter of personal taste. There are a whole group of painters today that paint old farms in a tonal way, using primarily earth colors. Although this approach can be quite interesting, I personally prefer to exploit color at every opportunity, as you can see here.

Solution

Here, as elsewhere, the solution is found by combining your knowledge of what usually happens under certain conditions with your keen perception of what happens when it does. This is as true in anatomy and perspective, as it is in the study of color. After years of studying and painting old buildings, I've found that there's always more of the building's original paint on the portion that's protected from the weather by a slight overhang of the roof than there is in the areas further down on the building. This is very logical, when you think of it, because during storms, this area is always slightly more protected. In this case, where the second story overhangs the lower level, we find the same conditions occurring. This gives us a great opportunity to play the warm yellows of the original paint against the cool colors of the more weathered sections.

Changing the Color and Value of the Sky for a More Dramatic Effect

Problem

Many amateurs are dominated by what is actually before them, and it seems to take some time before they realize that changes, even radical ones, can be made if it means a better painting. Many painters who do landscapes mostly in the studio feel that in going outdoors you can become enslaved to the scene before you. However, I think that this painting proves that this isn't necessarily so, for there was actually a bright, sunny blue sky the day I made this painting. I decided to change the sky for a more dramatic effect though, and the problem was how to go about doing this.

Solution

To solve a problem, you can't just arbitrarily change things. Before you even touch a brush to canvas, you must first know *why* you're making a change, and then be able to visualize how it will help your finished painting. Only then are you ready to paint.

Changing a sky from the one that's there to one that's more dramatic isn't that difficult once you realize that it's not only permissible, but there are many instances where there's much to be gained by doing so. Before changing anything though, just remember that the only rule is to be sure that such an effect *could have* happened.

Lowering the value of this sky gives the illuminated area of the house greater importance by contrast—a simple case of adding emphasis by playing down competing areas. I not only darkened the sky here, but I also made it slightly purplish. I chose purple because, being the natural complement of yellow, it also gives added emphasis to the sunlit portion of the old building. The purple sky is also a wonderful foil for the white lilacs on the right, and harmonizes with the purple ones on the left.

Bad

In this rendering, there's been no effort to exploit color. While attention was given to detail in the window, and to portraying a feeling of old clapboards, the color remained primarily a combination of burnt umber, Naples yellow, and white. The bushes are handled in a crude and insensitive manner, and there's no feeling that the same sunshine hitting the grass is falling on the building itself. The color possibilities within the window itself are also undeveloped.

Good

The colors in this old wood are really complex. In the cool sections, I used cerulean blue, Naples yellow, and alizarin crimson, tinted with white. In the sections where the old paint remains, cadmium yellow deep, yellow ochre, and Naples yellow predominate. Notice the cold blue (French ultramarine) in the cast shadows of the bushes at the foot of the window. I've only suggested detail in the window, but see how the cast shadow on the left-hand side of the green shade gives us a sense of space and depth. This was painted on a rough linen canvas, which adds to its textural quality.

Bad
In this sketch, the sky has been copied literally. Because of this, it now rivals and upstages the building, which was the subject of the painting. Also, because the sky was painted light, the white lilac bush has lost its punch. No effort was made to exploit the colors in the roof or sides of the building. And the figure is much too stiff because it was added later, without first-hand reference to the characteristics of a living human being.

Good
I painted the sky the color of a spring storm with French ultramarine blue, alizarin crimson, flesh, and yellow ochre. Not only is it important to get the correct color but it also has to be just the right value. Study the colors I introduced into the shadow side of the old building. Note the casual movement of the figure I painted. Because I did this on location, I was able to capture Emma's pose when she came out to see how I was doing. On-location painting also accounts for the authenticity of such details as the old apron she had tied around her in a manner so typical of years ago.

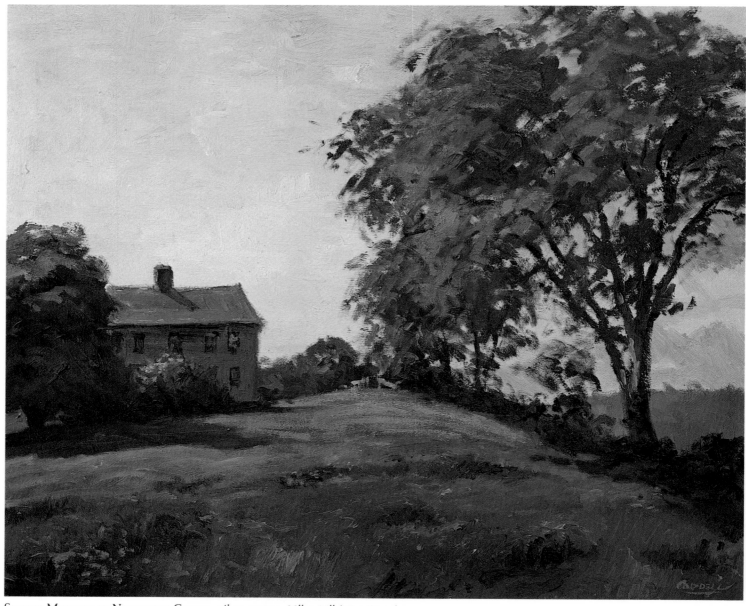

Summer Morning at Northwest Corner, *oil on canvas, 20'' x 24'' (51 x 61 cm).*

My main reason for painting this was to record one of the few remaining elm trees in our area. They were once such a dominant part of our New England scene and just in my lifetime, I watched them almost disappear. Their tall, graceful size makes even large farmhouses seem small by comparison. This is a typical local farm scene, and I wanted to capture it as the morning sun was burning off the valley haze. I wanted luminous color in the sky, *but* I had to handle it in a restricted way. Overdone, it would appear corny, like the old chromolithograph, "Sunset Over the Bay of Naples." Having defined my objective and potential problems, let's discuss how the final effect was accomplished.

Painting Exciting Colors in a Morning Sky

Problem

You may think that my admonitions are becoming clichés, but when I repeat a statement many times, it's because I see these mistakes so often in student work that I want to alert you to the possibility of it happening in yours. The problem in painting skies in general, and those of early morning or late afternoon in particular, is that their effect is extremely transient. This requires the painter to rely heavily on memory and knowledge in order to paint them. Because amateurs usually lack these qualities, when faced with remembering a fleeting effect, they invariably revert to an ordinary, mundane solution. In painting a sky, the safe and obvious solution is to make it "blue." In reality, however, as the sun burns through the morning mist, the lighting effects are varied and everchanging.

Solution

This effect was not there every morning, but when it was, it burned off rapidly. It's not easy to capture the sensation of a morning haze. You must be sensitive to unusual, beautiful, transient effects, and be able to put down what you see and feel after it's gone. Keep the following points in mind when painting morning haze: The light from the sun is warm in color. Also, when you look toward the sun, the sky is always much lighter than when you look at the sky in the opposite direction. Study the detail on the next page to see how I painted color into color to achieve this effect. As you experiment with color, whether you're painting skies or luminous flesh, you'll find that the secret is to keep your values within each area consistent. The critical decision in color is how much you can use without making it look garish or overdone.

Borrowing Subject Matter for Color and Interest

Problem

As you take to the outdoors, you may find yourself in a situation similar to the one that I found myself in. When traveling around, even locally, I usually ask permission of the property owners to go on their land and paint. It's almost always granted, and makes for good public relations. Early last summer, while out scouting for new painting locations, I stopped at a typical New England farmhouse and asked (and got) permission to paint it. I returned the following week, ready to paint, only to find that the owner, no doubt conscious that the farm would be recorded for posterity, had decided to make it neat and tidy—and, accordingly, had mowed the grass and chopped down all the colorful weeds and tall grasses.

Solution

The freshly mowed lawn just didn't go with the rustic house on the hillside—somehow rural farms just don't look right if they take on the appearance of a well-kept estate. Not to be outdone, I just turned around and used the field on the opposite side of the road behind me. Naturally, I had to consider a different play of light on it. Notice the crescendo of brightness as we go further up the hillside. The red clover was just the right cold red to echo the same color in the sky—I always try to repeat a color throughout the painting for an overall harmony and unity.

Bad

Most amateurs start right off painting the sky first—and to them this seems necessary and logical. However, I feel that it's practically impossible to make the correct decision on its color and value unless you have something on the canvas to relate the sky to. Also, many times it's painted too dark and rather ordinary, with little or no feeling of impressionistic color. The sky here is not only too flat, but it's also the wrong color blue—French ultramarine instead of cerulean. And, of course, there's absolutely no feeling of the colors created when the sun burns off the morning haze.

Good

In cases like this I don't paint the sky first, even if it seems logical to do so. It's almost impossible to paint the correct value of a light color on a white canvas. Instead, here I first indicated the values and colors of other items for points of comparison with the sky. When they were dry and wouldn't work into the sky area, I painted the warm sky with Naples yellow, cadmium red light, a touch of alizarin crimson, and white. Then I started working down from the top of the painting with cerulean blue. I superimposed a pale alizarin crimson over parts of this and worked the colors back and forth until I achieved the effect I felt was most pleasing.

Bad
Color changes and value designs can create a feeling of depth and distance in a painting. But without knowledge and application of these principles of perspective, your painting will look flat. In this sketch, because the value and color of the field is incorrect and it doesn't recede, it looks like a flat wall. Also, this shows how it would look if the painter didn't know enough to look behind him for a more interesting scene and so painted the uninteresting area left after the grass was mowed. The green is too monotonous, since no attempt was made to introduce variations of colors and values. Also, the brushstrokes are all horizontal, so there's no feeling of texture or depth to the grass.

Good
The darker greens I made with viridian and some burnt umber show the presence of clumps and hummocks in the field. Where the grass gets lighter as it climbs the hill, I added flesh to the green to pleasantly warm and neutralize the color. The flowers are painted mostly with alizarin crimson, plus a touch of cerulean blue in places. Here and there I added a bit of earth reds and yellows to indicate taller dead grasses. Notice, as the grass gets closer, how I handled it with upright strokes to indicate depth and detail.

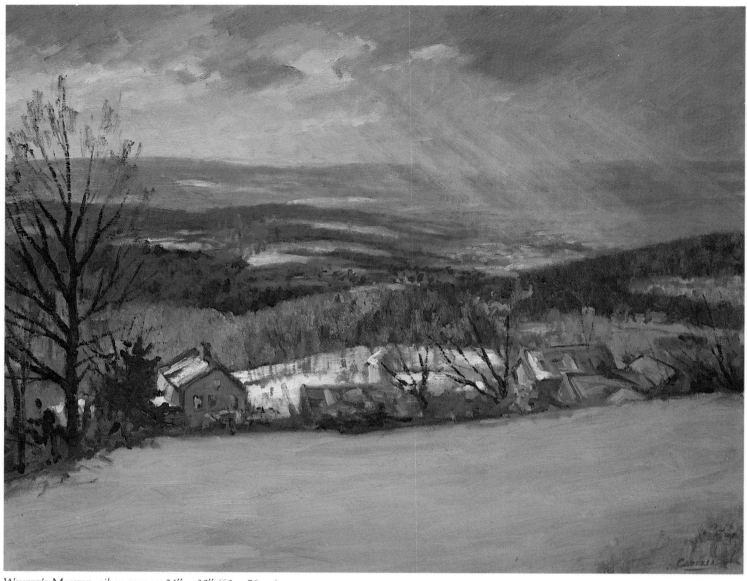

WINTER'S MANTLE, *oil on canvas, 24" x 30" (61 x 76 cm).*

I'm writing this commentary on a steamy, hot summer day, but I can vividly remember what it was like outside when I painted this scene. Although I've been painting outdoors for years, I don't believe I was ever as cold as I was the day I started it. The snow was very deep after the most severe blizzard of the winter that broke all records here in New England. At one time, I stepped back to view my work and, not realizing I was on a stone wall, sunk deep into a snow bank. I remember how the wind swept up the valley with a fury, and I questioned at the time who was sanest, the chap who paints this type of picture in a warm studio, or me. But looking at it now, and feeling good about the results, I must confess that I'd do it all over again. (I also painted this scene once before as a spring painting—you'll find it on page 155 of my previous book.) In the following keys, I'd like to discuss the authentic effects I've achieved by going to nature.

Getting the Correct Atmospheric Colors of Winter

Problem

At the risk of being considered repetitious, I must say again that the reason many painters lack a sense of reality in their winter paintings is because they don't go out and paint directly from nature. I'm afraid that they just don't look upon taking paint and canvas outdoors and trying to capture the beauty and mystery of nature in its varied moods as a personal challenge. However, once having done this, you'll realize the sense of satisfaction of knowing you gave it your utmost. Unfortunately, to many, painting is a means of making a product to sell. Because of this, the challenge is missing, and going outdoors, with its disadvantages, would be the difficult way of obtaining their end results.

I feel that the main problem when painting a subject like this is the fact that most amateurs fail to ask themselves, "Why am I painting this and what am I really trying to accomplish?" If the answer is to become a better artist with each painting you make and to better understand the subject you're tackling, then I feel that you're on the right track.

Solution

Nature has such diversified moods that, even though I have painted for years, I doubt if I could really achieve the authenticity I strive for unless I went out to study it directly. In principle, the same theory of aerial perspective applies to winter, but the colors are different. As in all seasons, in each successive plane that recedes, the value range shortens. That is, the lights get darker and the darks get lighter, until in the far distance they merge into a single color and value. The atmospheric color of winter in this painting is a muted purple, caused by the effect of the reddish color of the bare limbs and dead oak leaves still clinging to the branches on the basic blue of the atmosphere. Interspersed with this is the subtle blue-green of the fir trees, a wonderful complement to the warm colors. Notice how the colors of the landscape are echoed in the clouds, which gives the painting an overall unity.

Introducing Dramatic Lighting for a Different Color Solution

Problem

How many times have you gone to an exhibition or sidewalk show and noticed a sameness in artists' work? There's a great challenge to make each painting unique, and if you're not keenly aware of this, I hope to prod you in this direction.

It's especially difficult to make winter scenes unique because the branches are bare then and the skies often bleak. But I wonder how many of you have noticed that each of the winter paintings in this book is quite different? That's because I refuse to accept a stereotyped solution to problems and go outdoors all winter long to seek new inspiration from nature—and so should you. Remember, before you begin painting, you must always ask yourself, "What am I trying to say, and how can I say it in a unique way?" After all, aren't you trying to make each painting your best?

Solution

The painting that I made the week before this one was *Frosty Morning* (page 36), and I doubt if any two paintings were less alike. (I hope that by stressing this, I can get you to do more thinking about what you're going to paint.) This was an "open-and-shut" sort of day—the sun would poke through the clouds and light up different portions of the land at different times. My first decision was how to use this effect in my painting, and just where to plan my light patterns. Most of the time that the light was on the hillside by the farm, it was also on the foreground field. I decided to keep the foreground field in shadow in order to add drama and impact to the light just beyond the farm buildings. To balance this, I then chose to have the sun's rays coming down on the valley on the right of the middle distance.

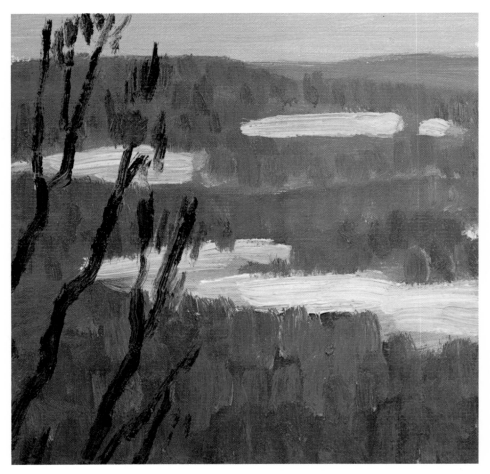

Bad
This sketch primarily lacks the necessary progression of values in each plane that would help give the illusion of space and distance. The color is poor, too, because the basic atmospheric color was realized with burnt umber and cerulean blue and therefore lacks the purplish cast you find in the detail below. Also, the sky has become a pure blue too abruptly; it lacks the atmospheric quality of color that would make this transition softer. The greens of the fir trees, being too light and yellow, are the wrong color and value.

Good
Here you'll notice that although the color of the snow is darkest in the foreground, it's still lighter than the branches of the foreground tree. I painted the snow with French ultramarine blue and alizarin crimson, and scumbled in burnt sienna for the warm branches and dead leaves of the trees. I made each successive layer of distance get lighter and bluer, until I reached the distant hills in the upper right, which I painted a light blue. This was achieved with the colder blue, French ultramarine, as opposed to the cerulean blue used in the sky.

Bad
The main problem with this is that the overall sameness of color and value creates visual monotony. This is because there's no sense of sunlight bathing some portions of the landscape, with other areas being thrown into cloud shadows; there's no progression of values to create distance, and the snow areas are too similar and general. In addition to all this, the handling is crude and insensitive.

Good
Here, you'll notice, I accentuated spatial planes, not only with color and values but with the play of sunlight over some areas and not on others. These effects are constantly changing in nature and demand great selectivity to make the most artistic composition. The cleared snow areas in shadows are bluish, and where the sunlight hits the trees, I've made the warm colors with Naples yellow, cadmium red light, and alizarin crimson. Note also the freedom of execution here.

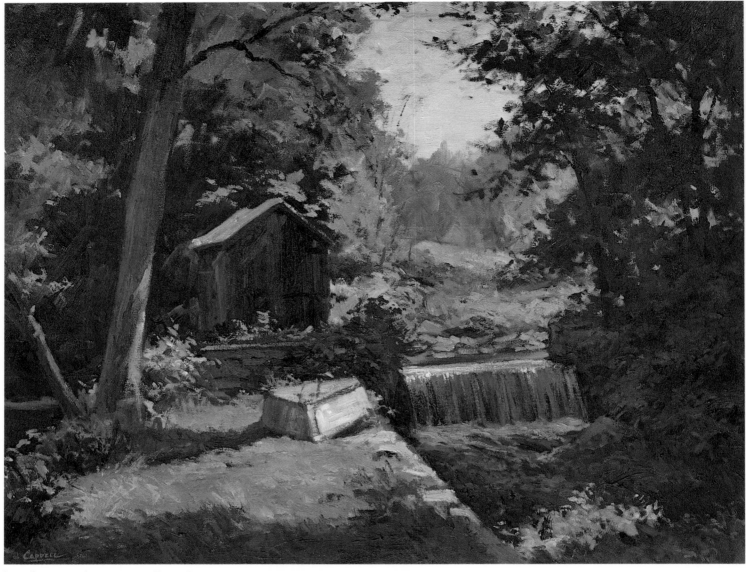

LATE SUMMER, *oil on canvas, 24" x 30" (61 x 76 cm).*

This was painted in late summer when the warm colors have started creeping into the summer greens, an advance indication of the dazzling display of autumn to follow. Although this is a delightful spot, and I've painted it many times and from many angles, you have to realize that quaint, charming subject matter and lovely color aren't enough to make an artistic painting. You must also take into consideration the fascinating value patterns created by some areas being bathed in sunshine and others being enveloped in shadow. Artistically, the patterns created by sunshine and shadows can be as interesting as the actual subject matter itself.

I am known as a painter of sunshine and light, but this effect is only created by giving the proper attention to the shadow areas. This is very important, and you must understand the problems involved and have solutions for them before you start painting.

Keeping a Definite Value Pattern as You Exploit Color

Problem

The value pattern in a painting is determined by the sun's position or the time of day. At certain times of the day, such as early morning or late afternoon, the value patterns are better than others. One of the first decisions you must make on the scene is to choose a definite value pattern. If you fail to realize this and don't make positive decisions, you'll end up with a rather poor record of the place. Unfortunately this is one of the areas where there are absolutely no rules. You have to develop an instinct for selecting the most desirable lighting on the scene.

This particular effect was possible only when the scene was backlit. An hour or so later, the sunlight would hit the front of the shed and wall and create a rather flat effect that wouldn't have given the sense of form to the masses and the outstanding value pattern that we see here.

Solution

When I saw this scene, my first thought was that, under somewhat of a backlight, the masses would become rather like steps, with the risers in shadow and the top surfaces like treads catching the sun. So by painting it this way, I was able to play beautiful light areas sparkling against convenient darks. After enough still-life training in dealing with solid forms in space, you'll be able to theorize these effects and paint them even when the sun has swung around to the side, or has dimmed, or isn't there at all.

The play of light over objects can create a wonderful feeling of form. Notice how I strategically used the light in the foreground to give a sense of depth to the scene. The viewer knows that the light in front of the boat has to flow over and down the retaining wall in order to be picked up again on the bushes in the lower right. Just remember when painting a backlight to keep your patterns big and simple and not disrupt them by letting too many lights break up the shadow areas.

Painting White Water Correctly in the Shadows

Problem

I've seen so many students painting this spot that I can absolutely predict the mistakes that 85% of them will make. The main one is to paint the frothy water coming over the falls *too light.* This will happen because they'll be thinking "white water," and will therefore compare it only to the adjacent darks and not to any other available lighter lights. But once everything becomes too light, we'll actually *lose* the feeling of sparkling light, because with all the passages screaming for attention we can't concentrate on any area in particular. This is another classic example of the mind of the viewer being so dominated by what he thinks he knows, that it prevents him from seeing literally. The mistake is so common that I urge you to watch for it in your own painting. The ability to spot this error and overcome it will greatly improve your work.

Solution

The thinking needed to make the correct decisions in cases like this is very easy once you understand the principles. You simply have to forget about the waterfalls being white water and ask yourself, "Does direct light hit it?" If it's not in direct light, white can *never* be intensely light. Again, thinking of these forms as steps, and considering their relation to the sun, you can see that light couldn't possibly fall on the water once it cascades over the dam. Only the edge of water, as it comes over the dam, catches the sparkling light of the sun.

Notice also that the colors and values on the rocks of the retaining wall, at the lower left of the falls, are much lighter than the water churning at the foot of the falls. See how the top plane of the water above the falls, which might be compared to the tread of the stairs, reflects the lovely blue of the sky above. To achieve the feeling of water flowing over the dam, I gave a lot of thought to the variations of brushstrokes I'd use. I also allowed some of the dark stonework, which was dry before I superimposed the water, to show through the falls.

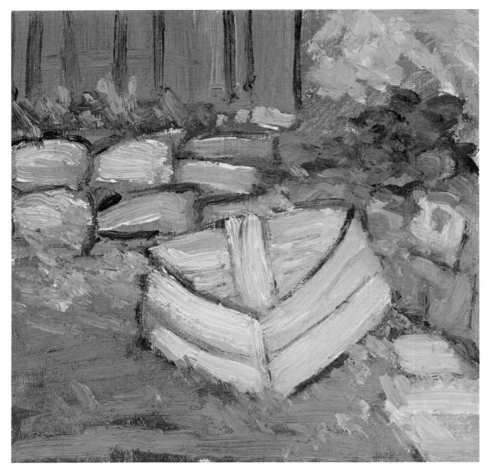

Bad
This sketch is too flat. As usual, facts have been recorded, but not the dramatic play of light upon the objects. Because values haven't been considered here, we've not only lost all sense of form, but the light passages have no darks to play against to give them impact and vibrancy. Color is only introduced where it's obvious, as in the vines on the stone wall, but there's no effort to make the rest of the area aesthetically pleasing through the use of imagination and poetic interpretation.

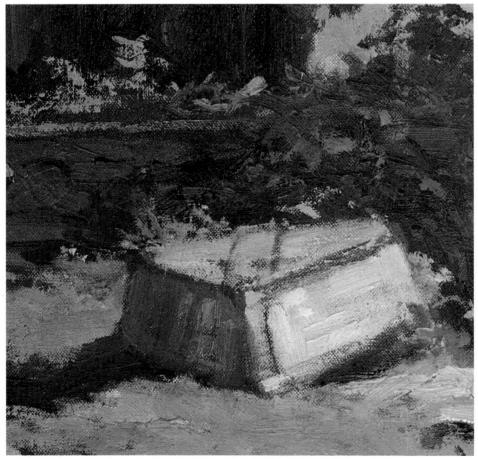

Good
I usually paint dark areas, such as the side of the shed and the stone wall, first with French ultramarine blue, alizarin crimson, and some raw sienna to neutralize them. Then, I introduce various local colors into this to indicate rocks and boards. Note the high-keyed cools and warms I used in the old white boat. The foreground was painted with permanent green light and cadmium yellow pale and white. Then, while it was wet, I painted light earth red into it to get that vibration of complementary colors. Study the colors on the light weeds around the boat and in front of the shed to see how casually they're indicated. Much of their impact comes from the dark passages around them that back them up.

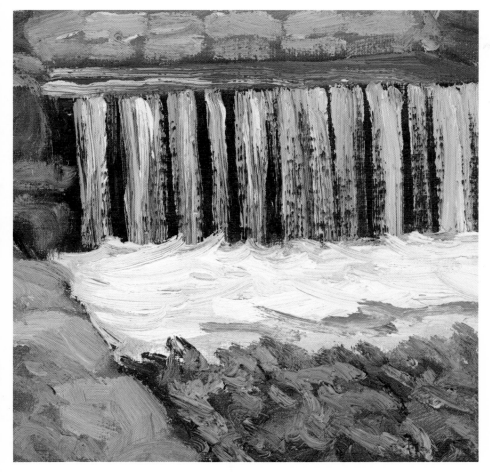

Bad

This sketch is quite weak, both in color and value. No effort has been made to exploit color in the water and, of course, it should never have been made lighter than the rock wall in the lower left that has sun shining on it. Furthermore, the design of the water coming over the falls is too repetitious and monotonous, and the rocks at the top of the illustration are too similar in shapes and sizes and are lacking in sunlit colors. The green foliage at the bottom of the scene is supposed to be under a cast shadow, and is therefore too light.

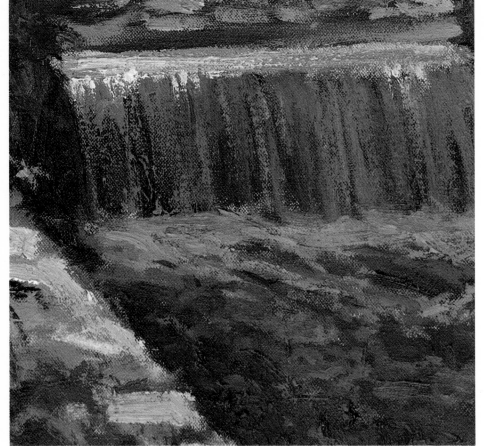

Good

Notice the colors that I used in the water coming over the falls. Over the dark base of French ultramarine blue, alizarin crimson, and raw sienna, I added cerulean blue, streaked with alizarin crimson. By restricting my lights to the few spots hit by sunlight where the water curves over the dam, I made the water really sparkle. The churning water at the foot of the falls was painted with flesh superimposed over a muted cerulean blue, but I left a few patches of dark French ultramarine blue to give greater contrast to the foaming water at the foot of the falls. I introduced some warm tones over the greens into the shadow area of foliage forward of the water. They're always a welcome relief in a predominately green painting.

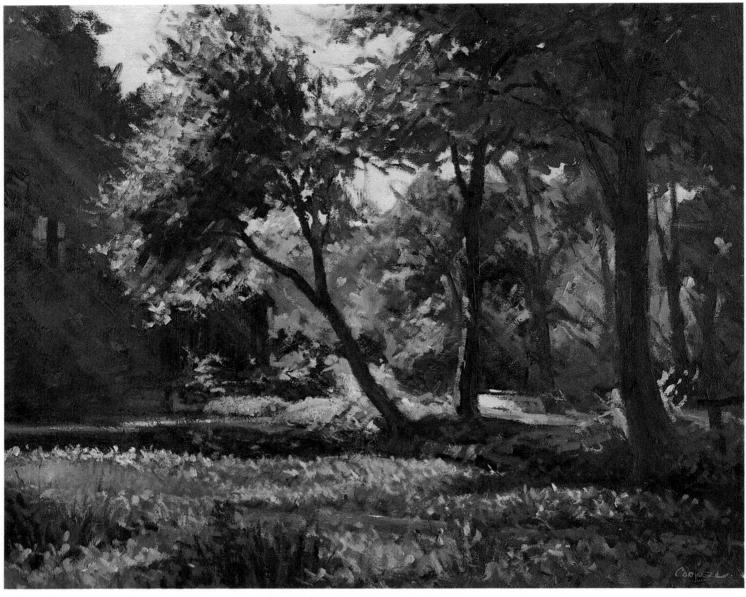

MISTY MORNING AT THE GATEHOUSE, *oil on canvas, 20" x 24" (51 x 61 cm).*

No matter how intriguing I find a place, I never interpret it the same way twice. Instead, I choose another season, another angle, or another mood. This is one of my favorite spots to paint. Another interpretation of this spot was used in the last color illustration in my previous book, and you'll find another view of it on page 92, in *Late Summer.* Arriving at the scene one morning, I found it bathed in a beautiful mist from the double falls that are just below the area in the middle

distance, where the gatehouse and rowboat are located. This gave me the idea for another treatment.

As you probably realize, a summer painting that has so many greens is difficult to paint. You must find any excuse you can for adding bits of warm color. Above all, you must be sure to get the values within each plane and between receding spatial planes (aerial perspective or atmospheric values) correct. Let's discuss these factors further in the following two keys.

Finding a New Color Interpretation With Morning Mist

Problem
In all these keys, I'm trying to convert you to a more professional attitude. Amateurs are content to record facts. You can see evidence of this in the questions they ask, such as, "How do I paint a tree?" or "What color is that building?" I'm not trying to teach you how to paint objects. I'm trying to get you to see, feel, understand, and paint the beautiful effects of light and atmosphere *on* that object. To paint something intangible like morning mist, you must analyze what is actually happening to the landscape, and so thoroughly understand the visual effect that you can continue to paint it even when those particular conditions no longer exist. In this particular instance, molecules of water were suspended in the air. Like curtains of bluish gauze, mist can give an unusual and artistic effect to a scene, making it more poetic and aesthetic.

Solution
By enveloping most of the detail of the distant bank in haze and mist, I simplified this area. This, in turn, gave more impact to the passages where the sunlight did sparkle—the foreground weeds, bush, boat, and trees on this side of the falls. The trick here is to make the darks in this area dark enough to be sufficient foil for the lights—yet not too dark, because they're in the middle distance and are therefore also affected by the mist rising from the splashing water. Learn to analyze colors under atmospheric conditions like this. Here, the shadow passages become bluish, but it's a reddish blue—basically a French ultramarine blue, *not* a cerulean. To explain that the area on the left was water, I added wind ripples in the current. They weren't always there but, as in all outdoor painting, if something good comes along, you must grasp and use it, if it helps the overall effect of the painting.

Concentrating on Values When Colors are Similar

Problem
I have to admit that when you first start to paint trees and woods, it's very difficult. All you see are thousands of green leaves and some trunks here and there—it really is rather overwhelming! I touch on many variations of this problem in this book, since it occurs whenever masses aren't clearly defined. The important fact to remember is that you must only capture the *essence* of the place, not put down everything you see. In outdoor painting, you use what is there if it's helpful, and improvise when it's not. The oldest adage in painting is, "When in doubt, simplify." I know that it takes years of painting experience to cope with all these problems, but through knowledge, examples of others, and hard work, I have learned, and I'm sure that you will also.

Solution
The solution to this problem is to simplify and organize my value patterns. Although the large tree in the foreground had a great deal of moss and lichen on it, which makes it light, I kept this the darkest value because it was nearest. If you analyze it closely, there are two more planes of depth in this little area. I kept the middle section a rather flat silhouette, even though it really wasn't, and my third and most distant plane was handled as lights that I saw through the darker values of the first two planes. When you're dealing with a complex pattern of greens, you have to see a simplified solution to the problem before you ever begin to put paint on. If you don't, you're just groping in the dark, hoping for a happy accident.

Bad

What a sad rendition of a subject that offers such possibilities! The sketch is much too busy and flat in color and value. The recording of facts, rather than aesthetics, has dominated the thinking in this rendition. We see all the boards and rocks carefully spelled out, but there's no feeling at all of the drama of light which is more important artistically. The color possibilities in the foreground weeds have not been exploited, and the handling is quite crude.

Good

The atmospheric blue you find in summer landscapes is French ultramarine blue, not cerulean blue. This color lightens the shadow passages and affects these darks more and more as they recede into the distance. The highlights in the tree and bush are primarily permanent green light, cadmium yellow pale, and white with a bit of flesh here and there for modification. In the foreground pickerelweed, we find alizarin crimson and white in the flowers, and cerulean blue on the portions of the wet leaves that reflect the sky color. Note how I always manage to work a darker value adjacent to lights in order to make them sparkle more.

Bad
Here's an example of what happens when a painter is overwhelmed by the mass of foliage, and unable to organize a pattern or design out of the material available. The rendition is monotonously repetitious, both in color and design. As a consequence, there's no feeling or illusion of depth, atmosphere, and spatial planes at all.

Good
The solution to this and similar problems lies in design and pattern as well as correct value and color. There aren't many variations of color possible in a summer painting like this one, but I've still managed to take artistic license and place a few flecks of red on the edges of the tree trunk. The greens in the middle distance are dominated by French ultramarine blue from the mist rising from the hidden falls. A little flick of a skyhole at the top of the trees with flesh and cerulean blue gives an added spatial distance.

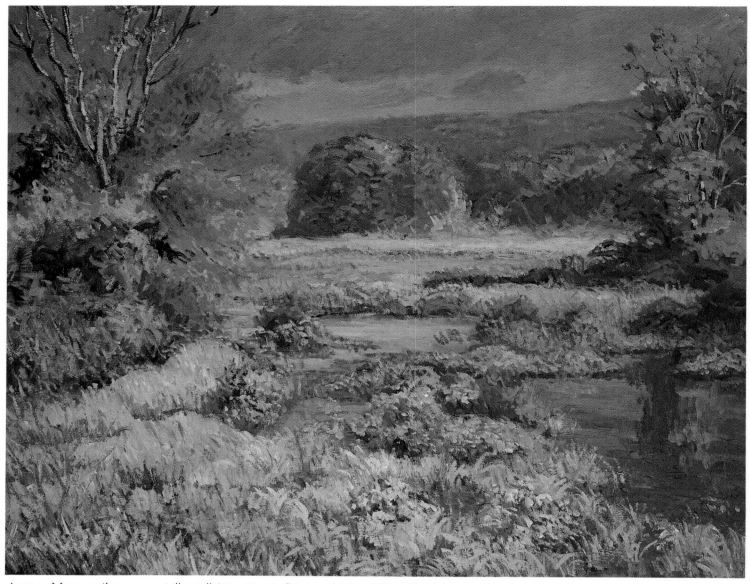

Autumn Mosaic, *oil on canvas, 24″ x 30″ (61 x 76 cm), Courtesy of Mrs. William E. Snyder.*

As you view the paintings in this book, I hope you're becoming aware of the great diversity of color and tonal effects possible as you paint the various seasons. A point I'd like to make is that I don't change either my selection of colors or the layout of my palette as I go from cold winter scenes to the blaze of colors you see here. I view my palette of colors as being like the keyboard of notes on a piano. Just as the piano keyboard remains the same while the notes change with each song, so my palette remains constant, but the colors I use from it differ with each painting.

If you've never seen a New England swamp in the height of its autumn splendor, you've missed one of nature's rare treats. The colors and patterns are overwhelming and a challenge to reproduce with our humble palette of pigments. Since I'm so greatly impressed with these colors and patterns, you'll find me referring to a swamp as "nature's oriental carpet." How to capture this varied color while retaining a consistent and harmonious tone of color in your work is the subject of this key.

Finding the Colors of an Oriental Carpet in a Swamp

Problem

A basic problem among amateurs is that they're hesitant to use bright, bold colors. Also, they fail to realize that the final solution is often the result of a series of colors, superimposed over one another, rather than just a single color. What I'm suggesting is that you basically follow the philosophy of the Impressionists, though, admittedly, some subjects lend themselves to this way of thinking and painting more than others.

As with similar subjects, the lack of definite objects in a swamp presents a problem to amateurs. You're really painting a big abstract design, and this is what must be sensed and concluded before the painting is begun. With everything screaming for attention, it's easy to play up all areas. But if you do that, the viewer's eye will jump all around, not knowing where to settle. Many times, answers to problems like this aren't easy to give, because they vary under different circumstances. What I do hope to impart to you, however, is that there's a much greater problem and challenge involved here than just making a record of the place. The study of patterns of values, the play of colors one against another, and the decision of what is to be emphasized— all this must be taken into consideration along with the original idea of making a painting of a swamp.

Solution

The complexity of trees, shrubs, weeds, and grasses in this type of subject gives us one of the greatest opportunities to perceive and paint beautiful color. The main point is that you must think of it as a mosaic of colors, as many little strokes of color that merge together for the final effect seen by the viewer. To accomplish this, you must use long bristle brushes that allow you to release the paint readily onto the canvas. You must also have the artistic sense to be able to see and develop color from the slightest suggestion. To give you an example, the section at the far side of the swamp grasses, in front of the section of trees in reality, was composed of trees that died when the water was raised after a new dam was put in. As you can see, I saw them not as dead trees, but as many strokes of beautiful colors. Also, part of the emphasis of foreground light and brilliance was achieved by holding down the value of the distant hill and sky. Notice, too, that the warm colors of the foreground are repeated subtly in the sky. This gives a painting the total unity and harmony that is so desirable. Study the detail on the next page; that will tell you more than the printed page could of how I found and painted the complexity of colors in this subject.

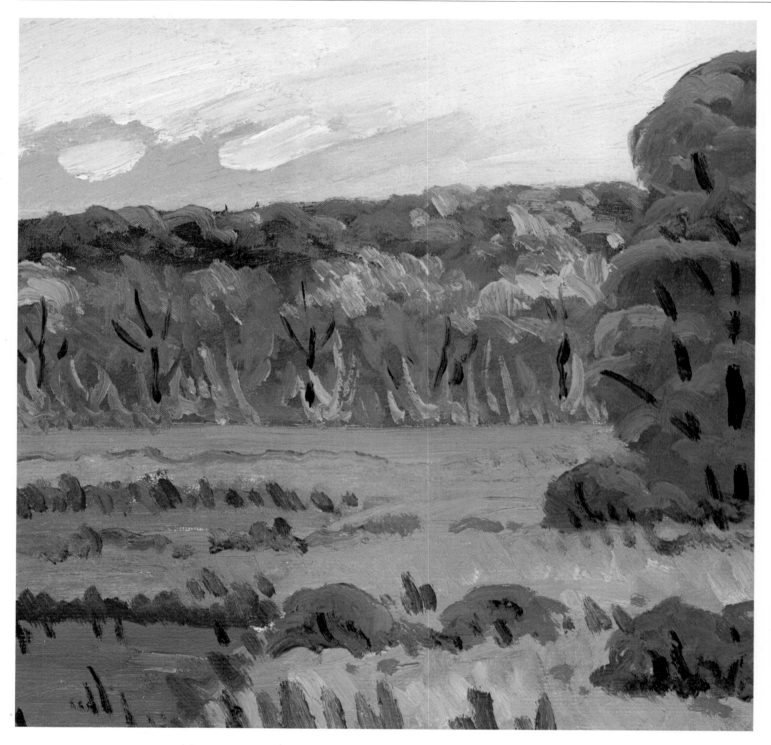

Bad

In this sketch, every section is shouting for attention. The sky is lighter and brighter than the swamp grass, and thus detracts from it. The middle-distance tree mass has no feeling of solidity because it lacks shadow areas, and numerous tree trunks are drawn in, which is a distracting, unnecessary addition of detail. The distant hill is lacking in atmospheric colors and values. The execution of the marsh grasses is too plain and simple, lacking the sensitivity to the complex color that you see in the detail opposite. The same can be said about the water. Generally, the sketch also lacks a feeling for the various textures of the swamp.

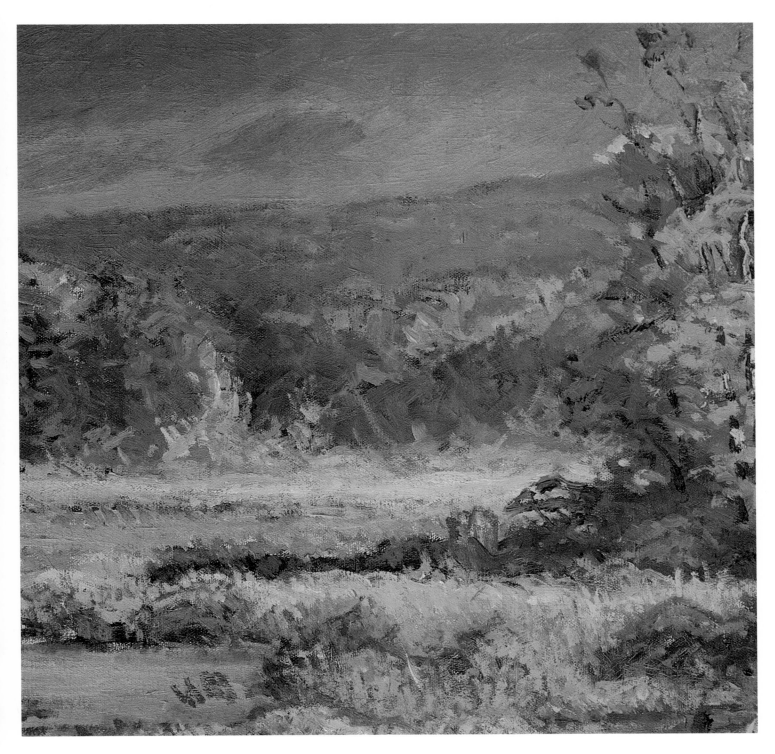

Good

In this enlargement, you should be able to study the strokes of the various colors that I used. I particularly want to call your attention to how the brilliance of the grassy area in the middle distance is enhanced by the cast shadow of the tree, which silhouettes the bushes against it. From this cast shadow value, we step back to two more reductions in shadow values in the distance, which gives us a greater feeling of spaciousness. The sky contains subtle repeats of the foreground reds, but is held down in value to add to the impact of the foreground.

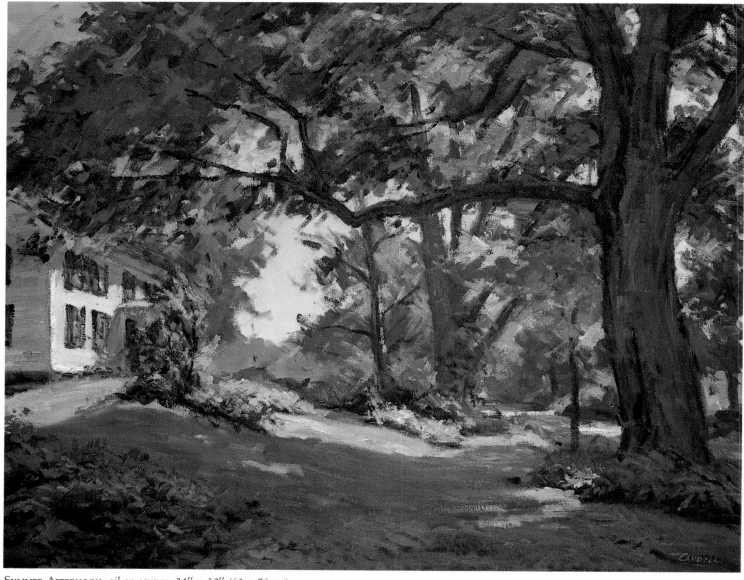

SUMMER AFTERNOON, *oil on canvas, 24" x 30" (61 x 76 cm).*

We're fortunate to still have a few majestic old farmhouses in our area that take us back well over 200 years in mood and feeling. As I've said repeatedly, painting in summer, with its preponderance of greens, is not easy. Because the building offered an excuse to break up these greens, and because it was a typical old New England farmhouse, I made it the subject of a demonstration I painted for students at a summer workshop. I'll go over some of the problems that were involved and show you how to avoid them in your own paintings of similar subjects.

I kept two main considerations in mind as I made this painting: (1) The plan of the design and amount of light patterns I was to use in the composition, and (2) my decision to set off the color of the old farmhouse as a delightful relief to the dominance of greens found in the summer. I'm always reminding you to take advantage of the colors in buildings, but it's so important that it bears repeating.

Handling Color and Detail in Buildings

Problem

In these examples I'm not discussing what mistakes are made from theory, but I've actually had students out on location at these spots and have seen from experience what they do wrong. I was absolutely amazed during my workshop at how many students were overwhelmed when they had to draw a house *above* eye level. Many actually drew it as I show on the next page. Then they labored so over such things as details in windows, completely missing the important possibilities—like the wonderful colors they contained. It takes amateurs a long time to know what to spend time on and what not to. Another common mistake was in not painting the shadow side of a yellow building dark or cool enough. Most of the students just painted the shadow side a deeper yellow, such as raw sienna, completely missing its wonderful, poetic color possibilities.

Solution

Your first impression is probably that this farmhouse is drawn rather loosely. If you can draw well, you should execute it freely so it doesn't attract undue attention in the overall picture. Remember to let the viewers do some of your work for you. They'll "see" a great deal of the detail in areas like windows and walls. If you lead them far enough along, their subconscious minds will provide the detail that they know should be there. The shadow sections of the house were painted in cool colors first, and then the local yellows were painted into it while it was still wet. Notice the cool shadows on the roof reflecting the blue of the sky. The area where the sunlight splashes on the front of the house is actually lighter than any part of the sky in the surrounding area.

Creating Sparkling Sunshine by Limiting the Amount of Light

Problem

When you're used to painting in a studio, the problems of the moving sun and shifting light patterns outdoors seem insurmountable. Each year as my classes move outdoors, I reassure my students, "Others have learned to cope with it, and so can you." The effect of sparkling sunshine in your painting is governed by the relationship of values between the light areas and the darks, and the areas in your painting you decide to have in sunlight, with the beautiful patterns they make. The time of day you select is very important, and sometimes nature has to be helped a bit by your own artistic ingenuity. If you change things a bit, my only rule is, do it in a way that *could* have happened.

Solution

In painting, as in life, the more limited anything is, the greater importance it has. I hope some of you are shrewd enough to discover that here, and elsewhere in this book, I often have more darks than lights in my paintings. The secret is to carefully compose the light areas you do settle on into an interesting and dramatic pattern and design. In this way you'll begin to achieve a pleasing aesthetic solution to the subject matter, rather than just make a record of the place. Notice in this painting how my light pattern starts on the distant field to the right of the large tree trunk, splashes across the road, climbs the sloping lawn and flowers, and ends up giving us beautiful colors on the old farmhouse. All these solutions had to be anticipated before I started painting in order for the result to be successful.

Bad

This is a classic example of what happens when you fuss over the wrong things and ignore the right ones. While spending so much time on the details saying "house," the glorious color possibilities were overlooked. And in spite of all this effort, the perspective of the house was botched up. Also, the color of the house is a much too simple yellow, with no variations other than the mustard yellow. Notice that the color is almost the same on both the light and shadow sides, with absolutely none of the coolness found in shadows.

Good

I first painted the shadow side of the house a cool blue-purple with French ultramarine blue, alizarin crimson, and white. While this was still wet, I superimposed the local colors of yellow ochre and raw sienna. In the lower section of the building, I introduced some permanent green light, which was being reflected from the sunlit lawn. The sunny sections of the house were painted with white, yellow ochre, and a touch of cadmium red light. Notice the difference in color between the white trim on the sunny side and the same trim on the shadow side of the house. Also, note that each window, although casually painted, contains a different pattern of colors.

Bad

In this sketch, there's absolutely no evidence of a shadow or light pattern—it's all painted one flat color. Because of this, it lacks a feeling of sunlight. The color handling also leaves much to be desired. It's much too ordinary and done in a manner I refer to as "house painting," inasmuch as the colors are used too flatly. There's no sign of the complexity of color mixture that comes from superimposing color over color on the canvas.

Good

Here the sunny greens run the gamut from permanent green light with cadmium yellow pale, to some that are diluted mostly with just white. Here and there I always manage to have a few warm passages, justified by painting grass that's been burned by the sun. The flowerbeds run the gamut of warm yellows through greens to flesh. Notice how I resisted painting individual "pretty" flowers—instead, simply by suggesting them, I let your mind see them. See how I introduced a dark alizarin crimson over the flowerbed and repeated a lighter version with cerulean blue on the left, in the shadows.

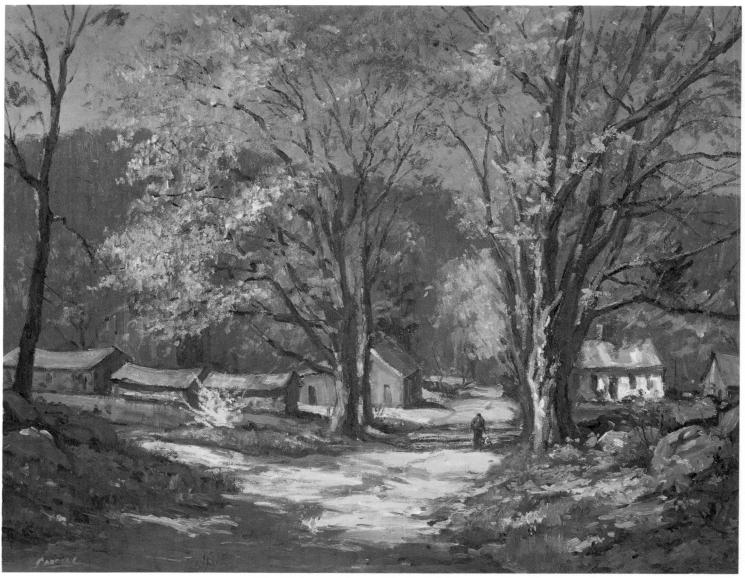

SPRING IN THE VALLEY, *oil on canvas, 24" x 30" (61 x 76 cm).*

It's easy to understand why early cultures had celebrations of spring. After the long, cold winter months, spring is the renewed promise of a rebirth of all the beautiful colors of the seasons ahead. If you don't live in a section of the country that enjoys the varied color orchestration of the seasons, you're missing many wonderful painting possibilities. I compare the seasons to life itself, and spring is like youth. The colors of spring are fresh and sparkling, and the leaves are a tender green before they're subjected to the long hot days of summer. Like fall, spring is a rapidly changing season. The buds of one day are the small leaves of the next. Because the changes are so swift, it's better to paint a spring scene on several consecutive days, rather than space your painting sessions further apart. Although I usually don't stress speed in painting, because I want the student to think things out carefully, at times like this it's a great advantage to be able to analyze swiftly, and paint boldly and decisively.

Accentuating Spring Colors With Value Contrasts

Problem

The most common error students make before they begin a painting is not asking themselves, "Why am I making this painting? What am I trying to say, and how can I best go about saying it?" It's obvious that the point of this particular painting was to show the stunning effect of these beautiful big trees once again coming into leaf. The color of spring foliage is a light yellow green, and is different from that of other seasons. Part of the painter's problem is to consider how this can best be brought out: What colors and values can be placed adjacent to the main color to enhance the total effect? These are problems that must be dealt with before you begin painting.

Solution

Once you're aware of the problems involved, you can do something about solving them. As I was driving along looking for subjects for a spring painting, I came upon a small sunlit tree. The entire hill behind it was in a purplish cloud shadow, and I thought how wonderfully the deep purple background brought out the color of the foliage. Although that effect never actually occurred here, I used it anyway because, as I've said before, my only criterion for making a change is that it *could have* happened. I held down the color of the green leaves on that hillside and played up the purplish color of the bare branches there instead. Notice how this brings out the light green foliage of the main tree. I even held the sky color down, but not so much that it looks stormy. Many white clouds drifted by as I was painting, and even though they were beautiful in themselves, I didn't include them, since they'd detract from my main statement of the trees. That's why I said that, initially, you always have to ask yourself, "What am I trying to say in this painting."

Accentuating Spring Colors With Complementary Colors

Problem

There are many ways you can direct attention to the main theme of a painting, once you decide what you're really trying to get across. Here, as in the preceding key, the problem is to enhance the feeling of spring. There we played up the light colors of spring through contrasting values. But you can also use complementary colors to intensify spring colors. To orchestrate your painting in the ways I'm suggesting requires a great deal of thinking and concentration. As I tell my students, you can't paint while discussing your social events of last week or what you are going to do next week. Every bit of your thinking and concentration should be on what you're going to do right now on your canvas. Painting is an intellectual, esthetical battle. I hope to make you aware of this, and to help you think correctly as you try to solve your own problems.

Solution

One way to enhance the color of the central object is by surrounding it with its complement. The color of young spring leaves is a lovely yellow-green. As you recall, in the preceding key, I told you that by visualizing the effect of a cloud shadow cast on the hills behind the trees, I was able to paint them purple, the basic complementary color of yellow. But this is a yellow-green mixture, and the complement of green is red. As a rule, I don't paint too many red farm buildings—it's used too often these days, and worked to death on Christmas cards. But this is one case where a red barn serves a useful purpose. Notice how I avoided a garish, freshly painted look by subduing the red with variations of gray for a more weathered effect. The cool yellow-green of the foliage was also brought out by its comparison to the warmer yellow of the forsythia bush in front of one of the old buildings. Forsythia blooms come in handy, because they're so typical of springtime.

Bad

With the distant hill in full sunlight, there are no darks for the foreground foliage to register against. Too much time was spent showing that small trees grew on the hillside, rather than considering the most appropriate color and value to use on the hill. A very common mistake among amateurs is to make tree foliage too spotty and repetitious, as it is here. Also, many times students mix the wrong greens simply because they lack the right color paint in their palette box—too many paint sets are equipped with cadmium yellow medium instead of cadmium yellow pale and deep. This is an unfortunate economy, because there's no way you can remove the warmth from a bright yellow to get the subdued, greener effect of cadmium yellow pale.

Good

The most important thing I did here was to keep the background hill dark by imagining it covered with a cloud shadow. This strategic manipulation enabled me to paint it a dark, cool purplish color, with French ultramarine blue and alizarin crimson, and with just a touch of permanent green light for some leaves. This purple, being a natural complement, brings out the vividness of the yellow-green leaves, which I painted with cadmium yellow pale and permanent green light. The dark tree trunk on the left makes the background hill appear luminous by contrast or relativity.

Bad
The green foliage of the tree is not only crudely handled here, but it fails to stand out for two reasons: First, because of the lack of contrast in color and value discussed in the preceding key, and second, because no complementary color was introduced in the buildings to intensify the color of the pale yellow-green trees. The tree trunks have been badly handled. Their limbs are repetitious in shape and direction; there's no feeling of sunlight—through strong cast shadows and very light areas—that would give a greater sense of form, and nothing has been done to exploit the many colors in the bark.

Good
You can see in this detail how the red buildings enhance the color of the yellow-green leaves. I tempered the basic red color with cerulean blue for a weathered gray look. Also, notice the colors I used in the tree trunks. Various warms are used on the side illuminated by the sun, while greens and purples are painted into the basic shadow color. Study how the very manipulation of the paint gives a feeling of solidity and rough texture to the bark. Compare this strong handling to the soft, lacy treatment of the foliage. How the paint is applied is ultimately important, too, in contrasting the textures of objects.

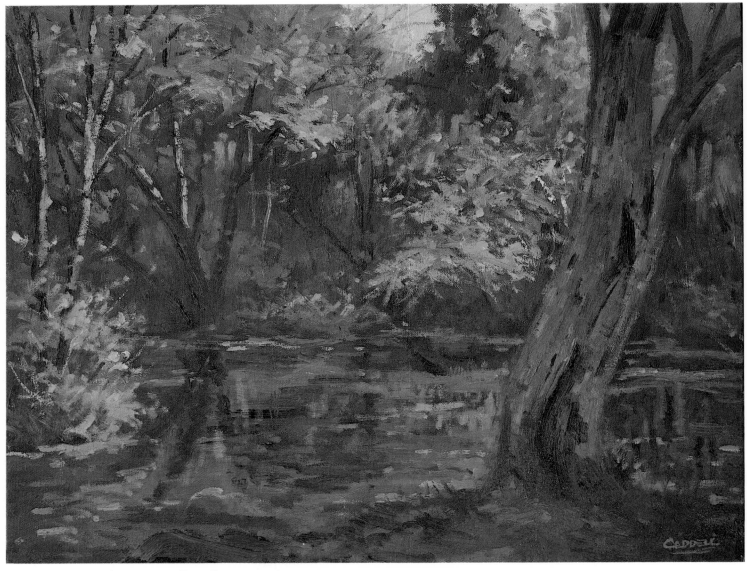

AUTUMN PATTERNS, *oil on canvas, 16" x 20" (41 x 51 cm).*

Again, this is the type of painting I enjoy for the sheer challenge and satisfaction of being able to cope with its problems. Although I'm a dedicated realist, as you can see from my work, I'm also deeply concerned with the abstract design and patterns of nature, which I consider rather like the grammatical structure of a sentence. They have to be well thought out in order for the painting to amount to anything worthwhile. As I've said before, this is the type of subject the average amateur finds so frustrating. It's really an exercise in color, pattern, and abstract design, as I shall try to show you.

For those of you who wish to try painting autumn foliage, I caution you not to be overwhelmed by all the fascinating warm yellows, reds, and oranges. Remember to keep them balanced by the greens, blues, and purples that still exist in autumn and play a wonderful supporting role to the dominant brilliant colors.

It's sheer delight to spend days painting in a quiet nook of the woods, so let me go into some of the problems and their solutions with you so you, too, may find pleasure, rather than aggravating frustration, in a similar situation.

Painting Nature as an Abstract Design

Problem

I find that the overwhelming tendency of most students is to try to explain to the viewer too explicitly just what the item is that he's painting, rather than seeing the scene as a whole, and individual items as just part of a pleasing, abstract design. When there's too much concern with details saying "trees, bushes, and stream," the painting loses its beautiful artistic fluidity. You'll find many paintings of subjects that have few defined objects in them in this book. Amateurs find this abstract type of subject matter very frustrating to handle; perhaps, many of you have avoided making paintings like this, as I once did, for that very reason. However, once you learn to cope with the problems they present, I'm sure you'll find them increasingly fascinating, as I do now.

Solution

When I show my students an enlarged segment of a painting, as I do here in this book, it always amazes them how little explicit detail is really needed to define objects. As far as mixing colors is concerned, it's hard to give specific formulas. In most instances, the results that you see are arrived at by superimposing one layer over another, sometimes working wet into wet, and at other times wet over dry. However, I pay constant attention to the arrangement and proper value of the darks that the lights register against, for this not only gives us a feeling of bright light, but also of solid form. There are no absolute rules, as there are in linear perspective, that I can give you for treating abstract patterns successfully. And my solutions differ with each painting. But if I succeed only in making you aware of the principles to consider, I'll have helped you to become a better painter.

Learning to See Beautiful Colors in Tree Trunks

Problem

Although we're talking here about seeing the colors in tree trunks, the situation is practically the same as that of painting water dealt with in Key 2. The problem in seeing beautiful color in tree trunks stems basically from the inability to make a critical analysis of what you're trying to paint and, because of it, reverting to a simplistic solution. The result is that you paint the color that you *think* an object is (for some reason, the average amateur thinks of tree trunks as being brown!) instead of *really looking* at the colors in the object. Again, I blame this on lack of studio training which, I stress over and over, will enable you to see the colors that actually do exist.

Solution

If you study tree trunks first hand by going to nature, you'll see that there are many color possibilities and variations. The bark contains many colors and, depending upon the surroundings, weather, and time of day, different lights and reflected lights shine on the trunks. Also, some trunks contain added color in the form of moss and lichen.

I wanted to give this tree trunk a great deal of attention, yet keep it secondary to the center of interest. Therefore, I placed it in the foreground—but in shadow—so that the viewer first notices its color and texture, then passes beyond it to the beautiful foliage across the stream. Remember, don't think of what an object is but, rather, analyze it as a pure abstract shape and learn to see the wonderful color possibilities it contains.

Bad
This is what I refer to in students' work as being too "simple." The sky is like a blue wall hung behind the objects, the green tree is green, the orange tree is just plain orange, and the yellow foliage is the same color all over. No attempt has been made to see the lovely, complex possibilities of color that do exist and can be found if you look for them. In addition, the objects in this detail lack form because there are no value differences in the colors themselves.

Good
Here the evergreen tree behind the warm foliage has just the right amount of atmospheric blue in it to give it distance, without lightening it too much, because it serves as a foil for the lights in the foreground. The warm leaves on the left-hand side are darker because they're on the shadow side of the tree. Notice the use of flesh tones to indicate the sun shining on bare branches interspersed among the bright yellow leaves in the lower section. I've painted the same three main items here that appeared in the example above, but notice in comparison how the colors flow and interweave here in a beautiful tapestry of values as well as colors.

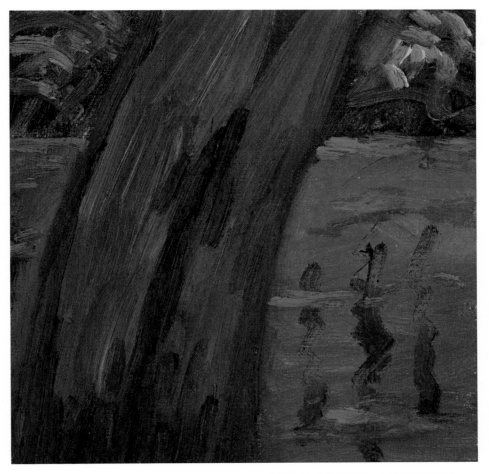

Bad

When the problem of finding color in a tree trunk becomes too complicated, many painters revert to the simple preconceived solution, like the one we see here, of painting tree trunks brown, foliage green, and water blue. These simple solutions are so synonymous with amateur painting that I hope to shock you out of this habit if it persists in your work. I hope you'll learn to see the beautiful color possibilities in tree trunks as are demonstrated in the example below.

Good

I first painted the tree trunk with Payne's gray and alizarin crimson, and into that added cerulean blue and permanent green light while it was still wet. The strokes were placed to give a feeling of a textured bark without going into too much detail. I did accentuate some cracks in the trunk with a strong dark made up of French ultramarine blue and alizarin crimson in order to bring this object into the foreground and keep it away from the distant bank. Notice that the tree trunk is registering against the water and foliage with both light and dark value differences. The water itself is a beautiful mosaic of colored reflection, with but a suggestion of blue sky as it shows through the dense trees.

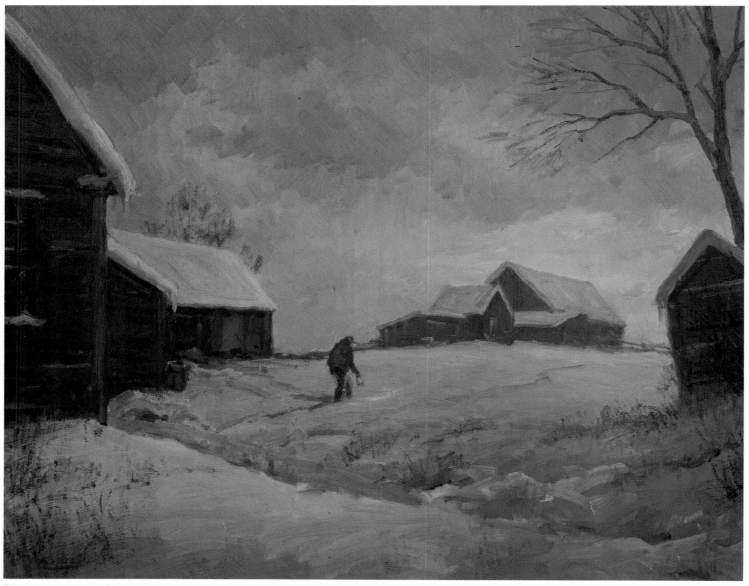

MORNING CHORES, *oil on canvas, 24" x 30" (61 x 76 cm).*

I believe that you're well aware of the importance I place on painting directly from nature—just about all my work is done on location. Occasionally, however, I enjoy a project such as the one you see here. Because "dawn's early light" is so fleeting, I painted this in the studio. And there were other logical reasons, too. This farm, I regret to say, has almost completely disappeared, but years ago I made a color sketch of it in the wintertime, and so was able to consult it for information. Since I've long been impressed by the hardy type of individual who built this great country and who, I am sorry to say, is fast disappearing, I decided to portray this rugged type, who had few of our conveniences, rising early on a cold winter's morning to do the chores. Also I wanted to prove to you that not all snow paintings must have the same stereotyped solution. You can occasionally try a snow subject that's a bit different, such as a moonlight or an early morning scene like this.

This project reminded me of the pleasant years I spent as an illustrator. I feel that this type of painting can be done successfully only if you spend enough time painting directly from nature to be able to synthesize it honestly and convincingly in the studio. In the keys that follow, I'll discuss the importance of color in this painting and how you have to think in order to solve its problems.

Using Color to Direct the Viewer's Attention

Problem

Painting, to me, is a means of communicating. Sometimes a painting just conveys a feeling of a hot sultry summer day; other times, as here, a more definite message is intended. So, before making a painting, you must ask, "What am I trying to say?" Once you decide *what* you're saying in the picture, you must get the viewer to look where you want him to, and hold down conflicting passages so they don't compete with the center of interest. In this painting, it's pretty obvious that the figure heading out to do the chores is the center of interest. Inasmuch as this activity is taking place in a scene rather limited in color—except for the sky, which is lightening with the early morning sun—this subject presents more problems than you might think at first.

Solution

Throughout this book you'll find problems and the solutions to them overlapping and intertwining as I show you how various paintings were made. As you recall, I discussed the use of a tonal climax in Key 3. Here I couple it with the only splash of warm color in an otherwise cool painting, and in so doing get the viewer to see the figure first and foremost. I easily could have featured the sky, since the sun brought subtle warmths into an overall cool scene, but I had to get the viewer to see the figure; *that* was my center of interest. I decided to place a lantern in his hand because its yellow glow gave me an excuse to splash the brightest and warmest color in the entire painting around him. (I could justify the lantern's existence by saying that he'd need it in the barns, which didn't have electricity.)

Relating Snow Color to the Sky Above

Problem

I always tell my students that when they make a painting, they're showing everyone who views it just how much they know and how much they don't know. The basic solutions to many subjects are based on keen perception, but not in this case. A painting like this shows how much knowledge the artist has been able to accumulate and how much he can theorize, understand, and paint from memory, without actually seeing the subject. That's why I'm trying to impart as much knowledge and theory to you as possible. So much is based on knowing a problem and its solution *before* you paint it.

Solution

To give you an example of how this is done, I'll tell you how I first painted the sky and then related it to the snow. I knew that the sky dominated such a large portion of the canvas that it had to have some pattern and design to it, yet it could not be so busy that it would compete with the rest of the subject.

Although this was a studio project, I spent much time studying morning skies. The sky had to have a delicate balance in design and value. I wanted color, too, but not so much that it rivaled the lantern. The sky also had to have some cloud formations, but could not become so busy and interesting that it would dominate the center of interest. I could have handled all this very differently if I hadn't decided to make the figure the center of interest. For example, I could have treated the sky as the central subject and made it stronger.

The general source of illumination is the glow in the morning sky. It reflects off the snow as it would off water. On the other hand, surfaces not facing the distant sky, such as the snow on the roof of the near building, become a darker blue gray, since they're illuminated from the sky above. With enough studio still-life training, you can theorize these causes and effects because they're based on logic and physics. But without proper study, you'd be hopelessly lost.

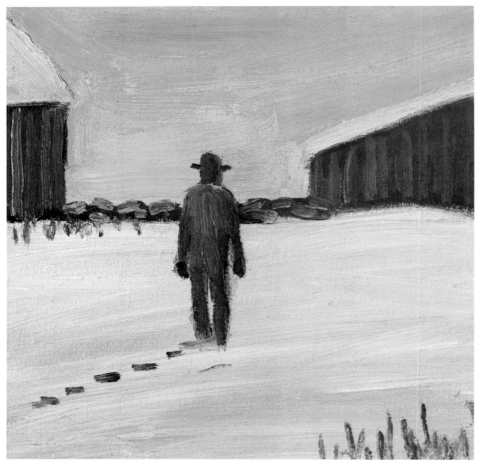

Bad
Here, we see evidence of how you might picture a figure going across snow with a sunrise sky behind him. This was an unfortunate decision. Because it's warmer and brighter, we see the sky before the figure. Also, the color and value of the figure merges with the buildings behind him. There are errors elsewhere, too. There's no relationship between the colors of sky and the snow it reflects into. And the snow on the roofs doesn't register against the sky because the values are wrong. Also, most amateurs paint figures uncommonly stiff and devoid of any motion or action, as has been done here.

Good
I painted the figure darker than the wall and building behind him. Although I kept the color rather restricted in this painting as a whole, I did put some red in his cap and orange in his face. But with other colors held down, the yellow glow from the lantern becomes the attention-getter I counted on. Notice the circular play of light on the snow due to the lantern's round base, and see how the color of the light splashes on the legs of the figure. Also, notice how I painted him in action, walking. You can almost feel him huddled up against the penetrating, still cold of the morning.

Bad

Two things dominate the thinking in this sketch—that the morning sky is warm and that the snow is blue and white. Unfortunately, there's *no* relationship between the two, as there should have been. (If the sky is warm, the snow would be warm, and vice versa.) The values are off, too. There's no difference in value between the snow on the roofs and the sky behind them. The buildings in the distance are the same value and intensity as the one in the foreground, which means there's no aerial perspective—objects don't recede. Also, the grasses are handled in a clumsy, heavy-handed manner. All in all, this is a rather insensitive handling of a very charming subject.

Good

The first thing you notice is the harmony of the relationship between the sky color and the snow color. The colors of the sky, painted with a subtle combination of Naples yellow and alizarin crimson, and grayed with cerulean blue, are reflecting on the snow in the barnyard just as they would on a body of water. The color and values of the snow on the roofs of the barns are painted darker than the sky so that there's a value differentiation between them. The warmer sky colors were introduced into them while the paint was wet. Notice the deeper value of the snow on the near building as it becomes a silhouette against the sky. I drybrushed the grass and weeds over the snow when it was dry, for a light, feathery effect.

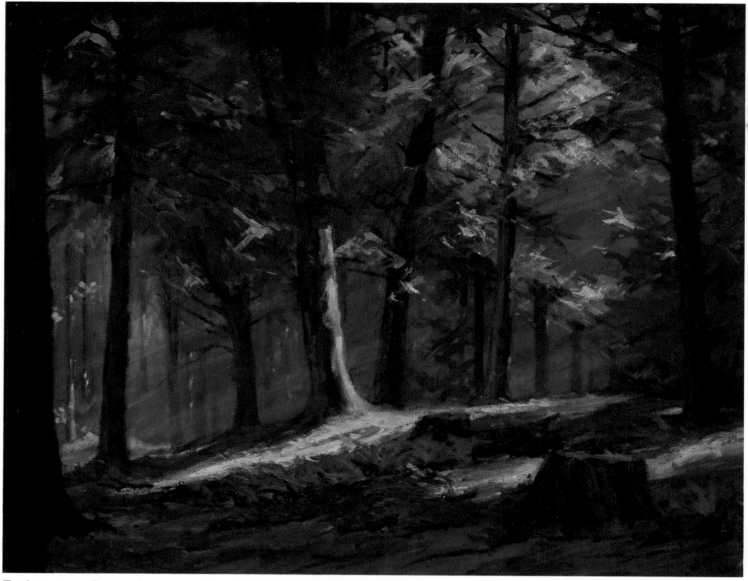

THE LIGHT IN THE FOREST, *oil on canvas, 24″ x 30″ (61 x 76 cm).*

This is part of the state forest that, fortunately, makes up most of our town and keeps it the rural area that I enjoy painting. This particular section of woods is another example of a spot I noticed while driving deeper into the woods to a small stream and pond I often paint. This brings up an important point I'd like to make. Years ago, when I first started painting, I used to drive for miles to find suitable subject matter. But these days, the longer I paint, the more easily I'm able to find paintable subjects close at hand. In fact, most of the material in this book was made within a ten-mile radius of my studio. This substantiates my philosophy that it is not just *what* you paint, but *how* you paint it that matters. In the following keys, I'll discuss how you can make a work of art out of just a portion of the woods, as I did here.

Painting a Hazy Morning in the Forest

Problem

As you surmount the problem of how to do it, the new and more important problem becomes what to do. Design and composition are important and are seldom found perfect in nature—they nearly always require the skilled help of the artist. A small section of the woods isn't the type of subject that an amateur is likely to tackle. It's not spectacular as subject matter, particularly in summer, when the dominance of green can make it monotonous. So the first problem, then, is one of interpretation—how to make it unusual and interesting. One of my teachers used to compare this situation to having a piece of meat: Before you can eat it, you must first decide how you're going to cook it—and there are many ways! But you must decide on the interpretation first, *before* you get underway. This is of vital importance, as I've told you many times before.

Another problem in painting a mood or making a dramatic interpretation of a scene is, of course, that the effect doesn't last. Remembering it, and then painting it from memory can take every bit of knowledge you have. You must be able to theorize logically what effects the light would create even when it's no longer there (or never was in the first place, but only imagined).

Solution

This is another example of what I mean when I say that I paint the effect of light *on* a subject, rather than just the subject itself. The effect I decided to paint here was that of the morning sun penetrating the haze of the forest. This gave me a mood or feeling, rather than just a portrait of trees. I've dealt elsewhere with the use of light rays, but notice here that, because I painted them so that they passed behind some trees and in front of others, I got a marvelous feeling of space and depth. Design and aesthetics were my next consideration—where the light would play, and what sections would be held in shadows. Notice how my design is diversified, with the lights being grouped high in the trees on the right-hand side, and low in the distance on the left. I hope you realize that the placement of trees and design of light was not just as you see it here—I had to do quite a bit to help it.

Taking Advantage of Warm Colors in a Green Painting

Problem

Though not wanting to frighten you, I must confess that making an all-green summer painting like this is hard, for the dominance of green can be monotonous. It took me some time to master this type of subject, and it undoubtedly will take you a while, too. All I can say is—stick with it. You won't conquer the problem by avoiding it or walking around it. If you're serious about painting, I hope someday you become proficient enough to know that you can come up with a satisfactory solution for *any* subject you wish to tackle.

Solution

In the pure mechanics of optics, when the eye is saturated with any one color, there's a great tendency and need to see its complement for relief. These summer woods are all green, and red, of course, is the complement of green. But the red you add doesn't have to be a bright pure vermilion. It can also be a burnt sienna with touches of muted alizarin crimson, as you see here. The important thing is for you to see the reds in the scene, know that they're necessary, and introduce them into your painting. In this painting, we find reds in the dried-up, dead pine needles, both in the trees and on the ground. Another charming note of color, one you'd never be able to imagine without being there, is the warm color found on the shadow sides of the tree trunks when the sunlight is reflected up from the pine-needle carpet on the ground. Of course, you must always remember to see warmth in lighted areas, since they're bathed in radiance from the sun.

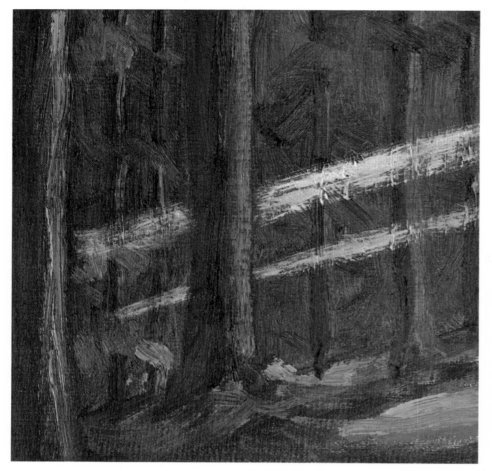

Bad
In this sketch, the brown trees are all the same color, and each has a light and dark side, regardless of whether sunlight was hitting them or not. The green foliage is too dark, and there's not enough contrast between the light and dark areas. When amateurs are finally daring enough to introduce rays of sunlight, they often wind up making them too harsh, as you see here.

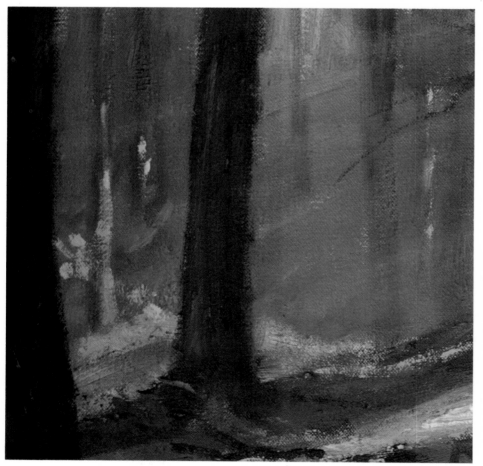

Good
Notice the sparkling effect of sunlight striking portions of tree trunks and foliage. The presence of haze here merely accentuates the principles of aerial perspective. The basic haze color is a muted French ultramarine blue and white, and I drybrushed it over the underpainting after it dried, for a soft airy effect. Since the tree trunks get lighter as they move further back, this also helps the feeling of space and distance.

Bad
The colors here are very monotonous. The greens are almost all the same; also the browns show no variations to make them interesting. It seems difficult for students to make light areas brilliant and sparkling; many are only rendered a lighter version of the shadow color, as you see here.

Good
Here you can study more closely how I got the effect of warm sunlight splashing on the forest floor. The light from this gives us the beautiful warmth of burnt sienna reflected into the shadow sides of the tree trunks. The shadow color of the pine needles is basically burnt sienna, with variations ranging from alizarin crimson to yellow ochre. Note, too, the different hues of green in the ferns and groundcover.

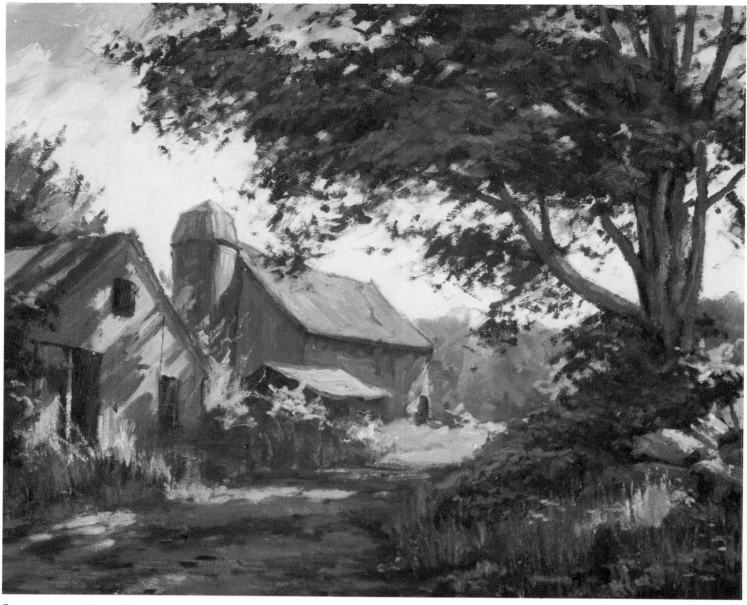

SUNLIGHT ON THE PAST, *oil on canvas, 20" x 24" (51 x 61 cm), Courtesy of Mrs. Foster Caddell.*

I never make a painting with the idea that a certain subject will sell well. Instead, I always try to make the best possible painting of a subject that interests me, and I feel this has been one of the secrets of my success. As I was getting the last of my material ready for this book, I made this painting as a demonstration for one of my classes, following the procedure I showed you in the beginning of this book. I usually paint about an hour or so at the beginning of each class, working over a period of several sessions, and painting directly from the subject matter in order to show students how a painting is brought along step by step. Even though I used to be a rapid painter, I've since slowed down. So in my demonstrations, I work

at exactly the same pace as I would if I were painting for myself and never resort to a quicker, simpler solution because of the pressures of time or because it's only a demonstration.

There were few changes necessary in this composition between the scene and the painting. The silo was no longer there, having long since rotted away, but I painted it in anyway to break the unfortunate alignment of the two roof peaks. I noticed the red bush on the right further up the road, and borrowed it to replace the white one that was there, to relieve the overall greenness of the subject (see the discussion in Key 47). I'll discuss these changes further in the keys that follow.

Getting the Proper Colors of Summer Atmosphere

Problem

It's not easy to take a flat surface and make the viewer believe he's actually viewing space, air, and distance, but the way to do it is through perspective—both linear and aerial. Linear perspective—as in the familiar example of the V-shaped, receding railroad tracks—is a matter of drawing. But since the subject of this book is color, our concern is with aerial perspective, and its effect on color and value. The problem here is to get students to see its effect, and then to get them to believe it and paint it, even when their rational minds tell them, for example, that distant trees are green, not blue. There's another problem in painting aerial perspective, too—some summer days are crystal clear, and the effect of atmosphere is minimal. On days like this, you must be able to understand the principles of aerial perspective well enough to paint atmosphere into a scene even when it isn't there.

Solution

Aerial perspective affects colors and values because when we paint air and distance, we're really painting the substance suspended in the air that we call "atmosphere." The greater the distance between viewer and object, the more atmosphere between them, and therefore the greater the change in their color and value. More specifically, if we begin with a full range of values from black to white in the foreground, as we paint objects further back, the value scale shortens. So objects in the middle distance plane might contain values ranging from dark gray to very light gray, and a still more distant plane might have only middle gray to light gray values. The theory is that the darks get light faster than the lights get darker. In summer, atmosphere makes the darker values of trees bluer, as well.

Using Patterns of Sunlight on Objects

Problem

As you've no doubt observed in my paintings, I paint the effect of light as it falls on objects rather than the objects themselves. However, students tend to do just the opposite. I know, because I took my class to this very location and actually watched them paint "old boards" on the building on the left. In fact, if I hadn't made this demonstration for them, they might never have realized the design possibilities inherent in the pattern of light and shadows *on* this building.

The main problem in painting the pattern of light and shade on objects is that the light is always shifting, and so the patterns are constantly changing. In addition, it's difficult for inexperienced painters to decide on a pleasing light and shade pattern. However, there's no one way to design these patterns—it all depends on personal taste and aesthetic sensitivity. An effective pattern will add interest and give a strong sense of design to your work.

Solution

During your first morning on a painting, you must be extremely sensitive to the varied light and shadow patterns that flow over the objects and change as the sun moves. Early in your work, you must decide on a pleasing pattern of these lights and darks and continue to paint them, even though they constantly change. One thing you must remember is that the directional thrust of the light pattern must point to the source of light—the sun—and must be consistent throughout the painting. As with all your painting, the light patterns must be warm in color and the shadows cool. Another factor to be aware of is the pleasing design that the lights make as they travel from one object to another. Notice in this painting how the splash of sunlight travels across the road, goes up over the grasses, and joins the light patterns on the barn. Beware of using a spotty, repetitious, uninteresting pattern.

Bad

Just about everything is wrong here. There's no feeling of distance, primarily because the distant trees are the same green as the foreground ones. The sky, although painted somewhat light, is still thought of as being only blue. The near tree foliage was painted over the sky while it was still wet, which made the greens too light. It was also done monotonously in a series of repeated blobs, and the bottom section of the tree leaves just touches the top portion of the distant trees—an unforgivable design mistake. The barn and road are too similar in color and lack interesting variations. Also, the white flowers on the foreground bush are much too important.

Good

I'm sure you realize by now that trees aren't always green. If you look at the trees in this painting, you'll find that those in the distant plane are basically two values—the shadows are blue and the lights are green. I painted the entire distant plane with French ultramarine blue and a bit of alizarin crimson, using a much lighter value here than on the nearer tree and bush. Then, I added the effect of the sunlight as it caught the tops of the tree masses. I used permanent green light and cadmium yellow pale for this, and painted it into the wet underpainting to reduce its intensity. Notice the red flowers on the foreground bush. By keeping them in shadow and changing them to red, they're now more harmonious and less important.

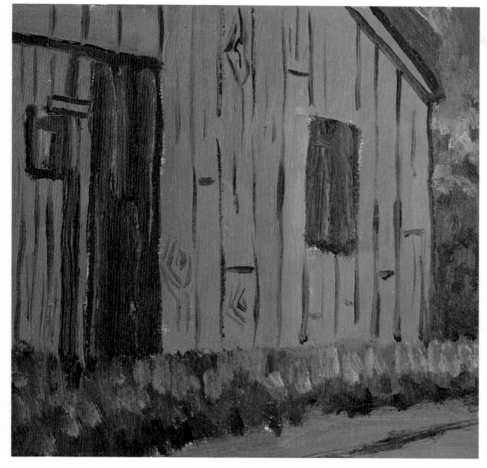

Bad
Here, time and effort have been spent on recording facts, with no awareness of the play of light upon the subject. Many times, the changing patterns of light so confuse the amateur that he ignores them and instead spends time rendering details that are less important. There are no variations of color or treatment in the grass, and the road is too harsh in design and uninteresting in color. Note the absence of detail in the section below, by comparison, and see how much detail we can do without here.

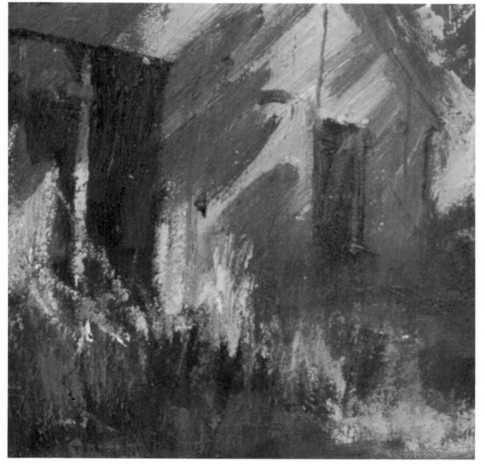

Good
The main point to note here is that the light forms an interesting and continuous pattern as it flows from the road, over the tall grasses, and over the barn. The shadow pattern is simple and in no way interferes with the design of the strong light. The old boards were painted two separate colors and values right from the start. The lights were flesh, Naples yellow, and cerulean blue, and the shadows, French ultramarine blue and alizarin crimson, with dashes of greens and earth colors. The luminosity of the shadows was helped tremendously by the deep color and contrasting value of the open doors. Very little detail is needed here—it's all supplied in the mind of the viewer.

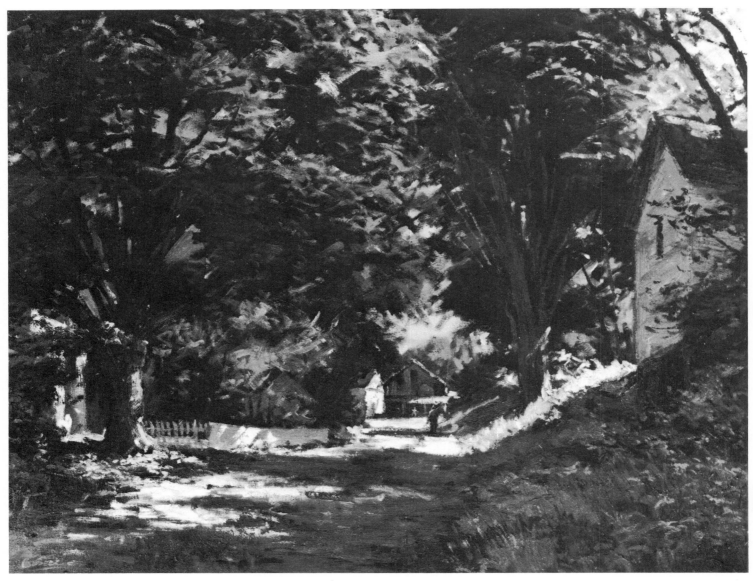

ROAD INTO PRESTON CITY, *oil on canvas, 24″ x 30″ (61 x 76 cm).*

Transforming Nature Into Art

Since my purpose in writing this book is to help your work look more professional, the most important principle I can deal with now, in this black-and-white section, is to show you how to make good paintings out of the material around you. In the Introduction, I said that, if the subject matter you paint from is 75% usable as is, you're lucky. Most scenes have to be modified and adapted to your painting. The ability to see picture possibilities and redesign the subject matter when necessary seems to be difficult for the inexperienced painter. In the studio, you can paint more literally because, if you want to arrange the subject a bit differently, you can do so before painting. But, of course, that's impossible outdoors.

I've repeatedly stressed that good painting is comprised of two elements. First, you must be a good technician. That is, you must be able to take paint and brush and draw anything, and mix any color or value and paint anything. This is your vocabulary—but it's not enough, for then comes the important factor of what you're going to say with this vocabulary. If you have difficulty deciding what to paint and how to interpret it, however, you're not alone. When I first take my classes to a location, they mill around for some time, trying to decide what to paint and how to translate it. However, as I've remarked many times, "If you can't make your painting better than a photographic record of the place, use a camera."

If you find this phase of picture-making difficult, forget about painting for a few days and go to various spots with just a pad and pencil. See how many interesting picture possibilities you can come up with. Concentrating on pictorial composition will help you make better paintings later.

You may also find it helpful to try quick thumbnail compositional ideas on a sketchpad before you begin painting. Remember, more paintings are spoiled in the first half hour because the student got off to a bad start. And what you do with the material available is what will make your painting better than someone else's.

One of my early teachers, C. Gordon Harris, was a whiz at seeing picture possibilities. In fact, a cartoonist friend of his once sketched him on a swivel chair, claiming he could be set down almost anywhere and come up with a good painting from any direction. You can learn a great deal from seeing how other, more experienced artists deal with the same problems. Just as I learned from him, I hope you can learn from me.

On the next few pages, I'll show you what I did with a subject to make a painting of it. I'll compare a photograph of the scene I painted with my painting, and explain what I changed, why I made these changes, and why it made a better painting out of the material at hand.

Photo for THE BROWNING FARM.

In this photograph, as so often happens, the material is spread out much more than I could actually keep it in my composition, even though my painting was made on a wide, 24″ x 30″ (61 x 76 cm) canvas.

Notice how the barn, with its interesting old metal cupola, is hardly visible here. Also, on the opposite side of the road, the large farmhouse was actually further out of the picture than I placed it, and almost obliterated with trees and bushes. In this photograph, the road takes up too much space and is most unin-

teresting. (In Key 17, I explained why I seldom paint a tar road.) Also, in this photograph, you can see the most uninteresting garage at the far end of the road. (Again, in Key 17, I discussed this in more detail.)

My basic philosophy is to retain all that's good and charming and eliminate or redesign all that's not. I think you'll agree that my painting retains most of the component parts of the place, but has been enhanced by my own interpretation of its rustic charm.

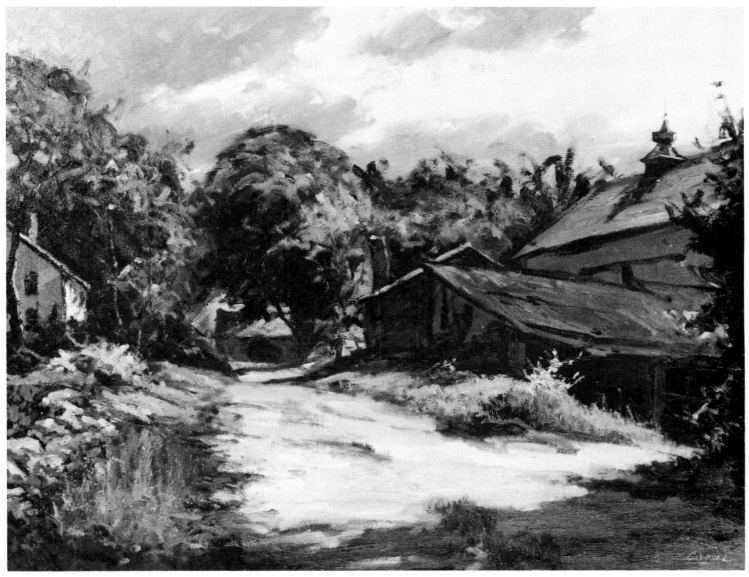

THE BROWNING FARM, *oil on canvas, 24" x 30" (61 x 76 cm). This painting is also reproduced in color on page 56.*

After designing the entire composition a bit closer, I next concentrated on emphasizing the play of light coming from the right and splashing on the weeds and the road. To enhance this, I theorized that there could be a large tree outside the composition casting a shadow over the foreground—a device I use quite often (see Key 19, for example). The trees and bushes on the left were simplified in order to show the large farmhouse, which was needed to balance the weight of the buildings on the right. Note how I placed a large tree in front of the house. The silhouette of its foliage against the sky gives us a directional thrust from that corner into the picture.

You can also see here how, with artistic license, I transformed the garage in the distance into a typical old barn. For the remaining bit of sky area, I needed a sky with some interest, yet one that wasn't too busy. Notice how I kept the main diagonal thrust of the clouds at a complementary angle to the thrust of the road. Remember, all these changes must be decided on and visualized *before* you begin your painting. Once you start, it's too late.

Photo for PRIMAVERA.

I hope this example will teach you how to see beyond the obvious and extract all the charm that a place has to offer. I've long admired the huge maple tree in the yard of this nice large family, who obviously make their living selling gravestones. When I decided to make a spring painting showing a lovely large tree leafing out, I decided to use this location.

Even though this isn't an old colonial farmhouse, it does have a great deal of charm. Once again, the sub-

ject is spread out too much for my canvas, so a bit of redesigning has to take place. In the photograph, you can see how everything is clamoring for attention, but in the painting, on the other hand, I made the tree the most important element. (To get the most out of this comparison, be sure to refer back to Keys 18 and 19, which show this painting reproduced in color and detail.)

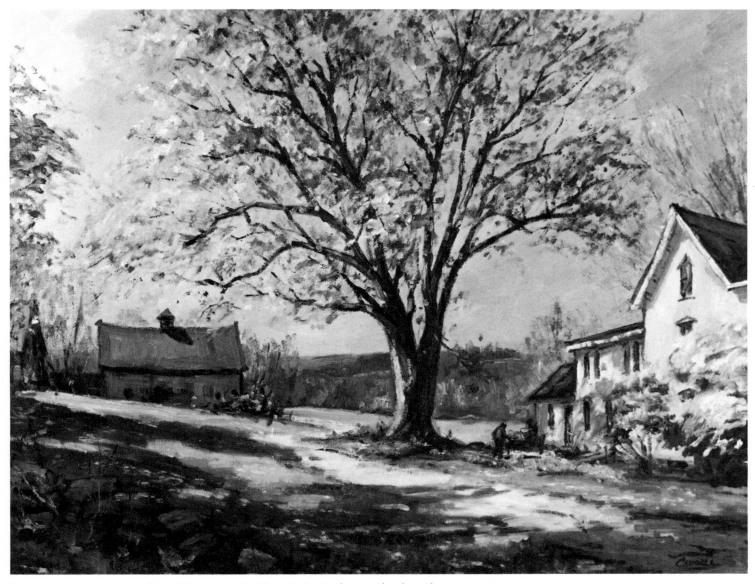

PRIMAVERA, *oil on canvas, 24" x 30" (61 x 76 cm). This painting is also reproduced in color on page 60.*

I hope you remember my admonition about deciding just what you want to say in a painting before you start it. Quite obviously, the center of interest here is the large tree. Because of this, I eliminated all other competing big trees on both sides of the composition. Once you acquire the necessary knowledge and experience to back you up, you'll find that major surgery isn't as difficult as you think. Here I eliminated all the monuments in the foreground, organized the tree shadow across it, and borrowed the stone wall on the lower left to balance the buildings on the right. Out of view, in front of the house, there was a gorgeous display of forsythia bushes in bloom. Because they're so typical of spring in New England, I moved them here to replace the bare bush on the right in front of the house. I think you can see that all the changes I've made help to feature the tree which, as I said before, was the prime reason for making the painting in the first place. Even the small figure gives us a feeling of the huge size of the tree by comparison.

Photo for Last of a Noble Breed.

This is a section of our village that could have been as interesting as I portrayed it, for the houses are very old. But little has been done to retain the charm we associate with the rural rustic setting of a town established in 1721. I chose this scene, basically, because it contains one of the few large elm trees that has escaped the Dutch elm disease. I took one of my classes out to this spot and made the painting you see opposite as a demonstration. I'll point out to you the changes I made, as I did to them.

The additions to the building added little to its charm. The main one appears to be some sort of garage, with a portable metal shed for lawn mowers and other equipment to its right. I redesigned these buildings, and removed the telephone pole and changed the paved road to a dirt one. Telephone poles don't interest me unless they add to the feeling of the subject and, as I've repeatedly stated, I avoid painting paved roads at every opportunity. Until I made this demonstration, most of the class couldn't see the possibilities of the scene and wondered just why I'd brought them here.

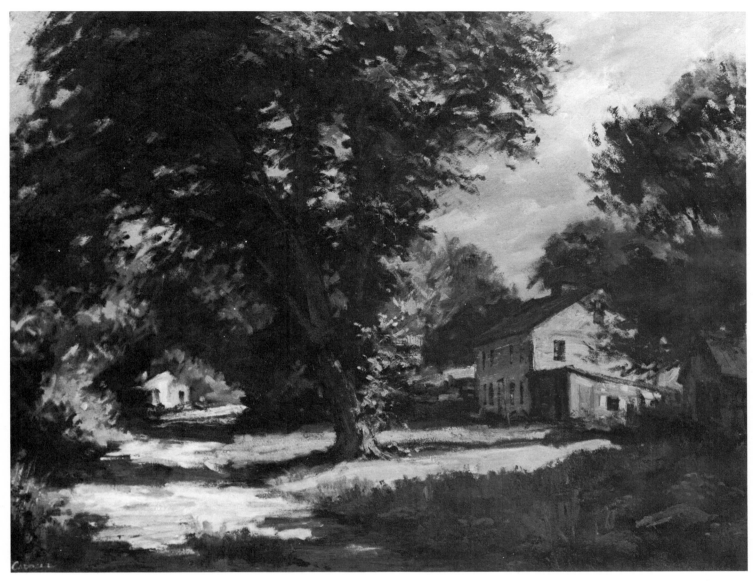

LAST OF A NOBLE BREED, *oil on canvas, 24" x 30" (61 x 76 cm).*

In this painting I tried to convey the charm that I feel this place should have. First, I eliminated the trees on the left that I felt conflicted with the great old elm. Then, I immediately concentrated on the pattern of light on the subject. Once again, I theorized a mass of trees outside the picture that gave me an excuse to design an interesting shadow pattern over the entire foreground. Notice how this pattern dominates the original pattern of the road. (I'd be interested to know how many of you noticed the light patterns on the road becoming smaller in size as they recede.)

Notice how I made the lawn on the lower left much more interesting than the plain area you see in the photo. The garage has become a basic lean-to shed and the metal building is now a small barn. To balance the group of buildings on the right, I painted part of a mill cottage showing at the far end of the road.

I wanted to include this painting in the color section, but there wasn't room. In color, you could see the fascinating color I found in the buildings and note how the warmth of the dirt road added interest to the predominately green summer painting.

Photo for SCHOOL'S OUT.

Many students have trouble finding suitable subject matter for their paintings. I used to, too—I vividly remember driving for miles to find a suitable subject. However, the longer I paint, the more suitable material I find close at hand.

As I've mentioned before, our area is laced with streams and ponds that were dammed up and used years back as part of the northern textile empire. I find much painting material in these wetland areas. To illustrate my point on the availability of subject matter, I'd like those of you who have my previous book, *Keys to Successful Landscape Painting,* to look at three paintings in it. *Morning Mist,* on page 123, was painted to

the left of this scene. (You may recognize the interesting tree by the water on the right side of that painting.) The view on the other side of this bridge was the subject of the painting *Storm's End,* on page 47. Beyond that was the locale for *Autumn Tapestry,* found on page 127 (not the painting of the same name here). In this book, *December Drama* (page 52) was painted further down the stream.

As I've often said, it's not what you paint that's important, but what you do with the material available. The cement bridge offered little aesthetic appeal to me, but on the facing page, you'll see what I've done with it in the painting *School's Out.*

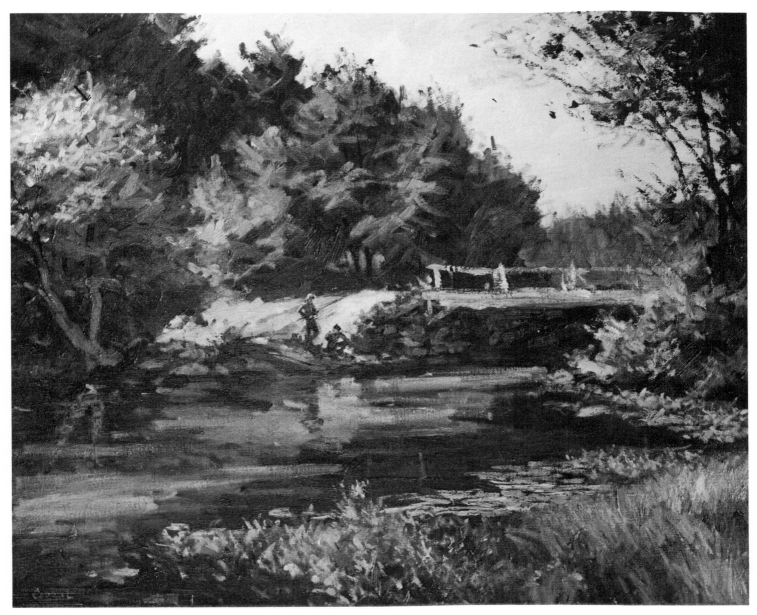

SCHOOL'S OUT, *oil on canvas, 20" x 24" (51 x 61 cm).*

The longer you paint, the more you'll realize the importance of designing a painting. Here I concentrated not only on the linear design, but also on the arrangement of masses and forms so that lights play strategically against darks.

This subject required fewer changes than many other subjects. The greatest change, of course, is the bridge. I felt that an old bridge would have a stone retaining wall. By adding some casual strokes, I made a bridge that might not please the state highway department, but surely makes a more interesting painting. I also spread the material a bit and made more than there really was of another atmospheric plane beyond the bridge.

Since this is a favorite spot for fishermen, I chose

this as the center of interest of the painting. The boys' brown, suntanned bodies provided a wonderful warm spot of color in this overall green summer painting. The dark jeans of the standing figure placed against the light sandy bank behind him gave us the tonal climax I discussed with you in Key 3. Even the sky was held down in value and color in order to focus attention on the figures. Notice the interesting poses and suggestions of detail—all done, incidentally, from memory as, unfortunately, no models came along.

Notice how the compositional lines let the eye flow into the center of interest. The variety of textured grasses and colors in the foreground become a beautiful pattern, yet don't detract from the figures.

OLD BOATS NEVER DIE, *oil on canvas, 24" x 30" (61 x 76 cm), Courtesy of Mr. Robert R. McDonald.*

Although this book is about landscape painting, I really enjoy painting other subjects, too. There's a wealth of material to be found around the waterfront, for example, and only time, or the lack of it, prevents me from exploring it further.

I realize that I keep reiterating that I'm primarily concerned with painting the effect of light upon objects. But I'm also particularly fascinated with the charm of our heritage that, unfortunately, is fast disappearing. Like most artists, I prefer to paint old buildings and boats rather than newer ones. Many of the old farms that I painted have since disappeared, and the spot where I painted this boat several years ago, I'm sorry to say, is now a bustling marina.

Conclusion

While working on this book, I gave a great deal of thought as to just what to say to you in this conclusion. If I knew each one of you personally, as I do my own students, my suggestions could be more personal, based on my observations of your work. In this instance, I can only make some general observations and trust that you'll interpret them in the light of your own ability and degree of competence.

I don't go to exhibitions very often, but when I do, I'm struck by the mediocrity of much of the work. I'm not talking about the big national shows, but those on the state and local level. To me, this means that there are too many amateurs who are settling on a level that should be much higher. To feel you've arrived before you really have, limits your possibilities and probabilities of becoming better. As I've said before, when you hang a painting up for all to see, you're telling the whole world how much you know and also how much you *don't* know. The only salvation is that most of the people viewing your work can't read what you're saying. To many lay people, an oil painting "done by hand" is practically an act of God.

Now, don't feel that I'm critical of all amateur work. None of us were born geniuses. All of us had to work our way up the ladder. The ones I feel sorry for are those who *think* they've arrived and are settling for making paintings to sell rather than growing, learning, and working desperately to become better artists. My attitude and advice is nothing that I didn't follow myself, as I hope you've read in the Introduction.

My reason for teaching and for writing this book is to share my knowledge with you, just as others have helped me. The letters I've received from remote places such as Alaska, Mexico, and the Canadian wilderness have made me realize how many people are struggling to paint and need help. Books and magazines are the only way some of them can study. Thus *American Artist* magazine and Watson-Guptill Publications deserve a great deal of credit for bringing information to people in these remote areas.

The hardest student to help is the one who thinks he's arrived. It's hard to admit to yourself that you're not quite as good as you and your relatives think you are, for this would mean lots of hard work to do something about it. In the past few months, a couple of incidents have occurred that I'd like to share with you to illustrate my point.

In my classes I prefer to work with the student who has been with me for a while because, obviously, it takes some time to get to know each student as an individual. I do, however, conduct workshops and accept people who write and ask me if they can come and study for only a few weeks. A gentleman of decided intellectual qualities did just this and, although I specifically said that my outdoor classes didn't start until the end of May, he came East about a month early. When he arrived, he showed me his rather plebeian work with which he was delighted and had much fun doing. After viewing it, like a doctor, I had to decide whether or not to tell him the truth. Since he lacked the fundamentals I've been stressing in this book, I suggested that he join the indoor classes on still life, since they'd help his perception of color and his ability to draw. But he'd have none of this training, and took off, saying he'd be back for the outdoor work. I thought at the time how difficult it is to help a person who won't be helped.

Another, a woman who had written with much persuasion and enthusiasm, on our first meeting, told me that her last teacher said she "drew too well." Now, in all my years of teaching, I've never had a student that I could say that to! The project we were then working on was an old rambling farmhouse, and I was greatly surprised by her inability to draw the perspective correctly. Her outdoor work showed none of the ability I'd expected based on her initial conversation. On rainy days our classes are held indoors and they're devoted to drawing, as I don't believe in having students work on their current outdoor paintings when they can't see the subject as they work. Although this is the instruction I felt the woman desperately needed, she didn't bother to attend. My observation is that ten years from now she'll be undoubtedly painting just about the same.

So often amateurs are overly concerned with having their style affected by studying with a teacher. But, with this attitude, they limit their advancement and close their mind to all new ideas. A classroom is not the place to preserve your individuality. Rather it's a place to get all the training possible to enable you to advance to the level where you can speak for yourself, in your own style, *after* you've left the classroom.

Throughout this book I've encouraged you, as a serious amateur, to get some good instruction in studio

EARLY SETTLER OF THE NORTHWEST CORNER, *oil on canvas, 24″ x 30″ (61 x 76 cm).*

work. But *don't* go to a class that copies prints or photos. There are classes around me that do this but, to me, it's "chewing gum for the mind," and I'd give up teaching before I'd conduct classes in such a manner. If you, as a student, are doing this, I'd like to give you some second thoughts on the matter. To me, copying has only one good reason to exist—and that is the way it was done years ago in museums by struggling students who were trying to pick the brains of the long dead Masters. In trying to recreate a Velazquez or Rubens, you had to try to imagine the way the Master thought and the reasoning behind his work. But to sit in a class and copy photos or other pictures is deplorable in my estimation. This makes a classroom become a painting factory or adult babysitting session rather than a place to really learn what painting is all about. It may be easier for the teacher and is certainly easier for students to copy, but the ridiculous part of it is that they're making "pictures" and exhibiting and selling them before they really know how to paint. You can see this type of work in many local exhibitions and, to the trained eye, they can be spotted in a minute.

Another type of class that pleases some students but hinders their ultimate advancement is that in which the teacher sketches out practically the entire picture and then helps "finish it up" so you're sure to go home with a painting far better than you're capable of. This, of course, again is not learning, and if you do this, you're only kidding yourself that you're an artist.

Let me share some other thoughts with you. One of the biggest problems in teaching is that students expect to make good paintings before they've studied and trained enough. This isn't possible in any other profession, so why should it be in painting? Believe me, the further you wish to climb the ladder to profes-

sionalism, the harder it gets. When students are disappointed that they're not doing better, I remind them that their advancement will be in direct proportion to the time they devote to painting.

Many amateurs want to study portraiture long before they're ready for it. Doctors that have been students remark that a portrait is as difficult as a major operation. Many students want to reach the top without the hard work that is necessary, but there's no easy way. What I'm really trying to instill in you is a great desire to paint better and a willingness to work hard at developing it. The fact that most of your viewing audience can't determine whether you paint well or not is no reason to fool yourself. When a singer comes out on the stage, most people only relate to the songs he sings. Only a small percentage of people are judging how well he's doing and how he compares to other great singers, or even to himself ten years ago. But those are the people that the singer should be thinking about—and those are the people that the exhibitor should think about, too.

My basic philosophy is that a good painter should be able to paint anything, just as a good musician can play anything. I'm as well known for my portraits as I am for my landscapes, for many painting problems are common to both areas. I hope to show you the interrelationship of these problems in my next book on painting people and portraits.

I sincerely hope that I've spurred on your desire to become a better painter, and your willingness to put in the necessary work and study to accomplish it. I trust that the problems and mistakes I've seen in my own students and presented to you here will make you more aware of your own shortcomings and help you overcome them. If this is true, then this book has served my intended purpose and we'll both be happy.

Index

Edited by Bonnie Silverstein
Designed by Jay Anning
Set in 12-point Palatino